IMAGES
of America

BERGENFIELD

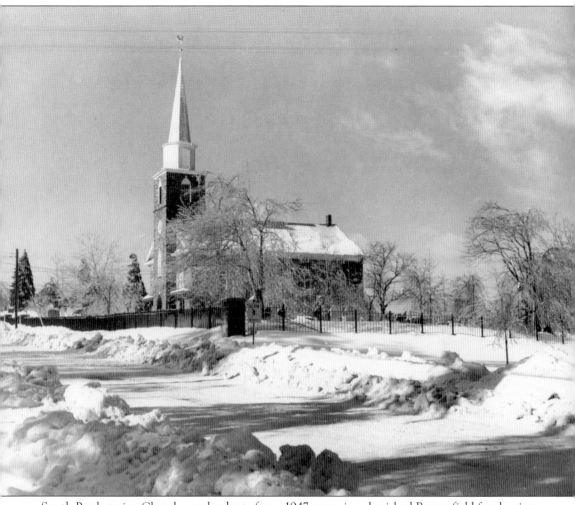

South Presbyterian Church, resplendent after a 1947 snow, is a cherished Bergenfield focal point. Known also as South Church, the 1799 landmark is in the National Register of Historic Places. (Courtesy of the Bergenfield Museum.)

ON THE COVER: The Bergenfield High School Marching Band has performed at the Macy's Thanksgiving Day Parade, the New York World's Fair, the Super Bowl—and down Washington Avenue in the Bergenfield Memorial Day Parade. (Courtesy of Eva Gallione.)

IMAGES
of America

BERGENFIELD

Jay Levin

ARCADIA
PUBLISHING

Published by Arcadia Publishing
Charleston, South Carolina

Printed in the United States of America

Library of Congress Control Number: 2022951379

For all general information, please contact Arcadia Publishing:
Telephone 843-853-2070
Fax 843-853-0044
E-mail sales@arcadiapublishing.com
For customer service and orders:
Toll-Free 1-888-313-2665

Visit us on the Internet at www.arcadiapublishing.com

This book is dedicated to the first responders and medical personnel who served and protected the Bergenfield community during the coronavirus pandemic and to the memory of those residents lost to COVID-19.

CONTENTS

ACKNOWLEDGMENTS

The Bergenfield Museum Society and Bergenfield Public Library made this book possible by opening their archives to me. At the museum, I am indebted to Joanne Thomas, president; Barry Doll, trustee and treasurer; and Patricia Doll, trustee and secretary. At the library, Allison Ballo, director; John Capps, head of adult services; Sabrina Unrein, adult services librarian; and Jen Murray, administrative assistant, gave their full assistance and support, and the present-day photography in these pages is by Jen. Thank you to all.

Others who helped immeasurably were Eva and Robert Gallione—Bob is a former mayor—and Michael J. Birkner, author of *A Country Place No More: The Transformation of Bergenfield, New Jersey 1894–1994*. Eva, Bob, and Michael offered photographs from their personal collections as well as their community knowledge and contacts.

Many of the postcards you will see in the book are from the collection of Alice Berdan and her late brother, Bill Berdan.

Additionally, the following people provided photographs or other materials: Tim Adriance, Howard E. Bartholf, Robert Blass, Meg Casper, Tony DeFeo, Mike DiBella, Janice Eberhardt, Frank Eufemia, Louise Fasano, Grace Di Maggio Kanapich, Maggie Kaplen, Bill Kirsch, Jim Kirsch, Thomas J. Lang, Michele Libonati, Andy Loizides, Kurt Luhmann, Anthony Marsilio, Peter Napolitano Jr., Jules Orkin, Tom Power, Anna Ramirez, Robert Rivas, Lora Schade, Bill Slossar, Janice Sorge, Brian Timmons, Jolynn Wexler, and Joanne Zucconi.

On the home front, my wife, Sue, supported this project from day one and offered valuable editorial suggestions.

Finally, thank you to the Bergenfield community for entrusting this project to an "out-of-towner." Although I live one town over, I am in "The Friendly Town" on most days. Whether shopping at Foster Village or the New Bridge Farmers Market or walking with Sue around Cooper's Pond, all roads lead to Bergenfield.

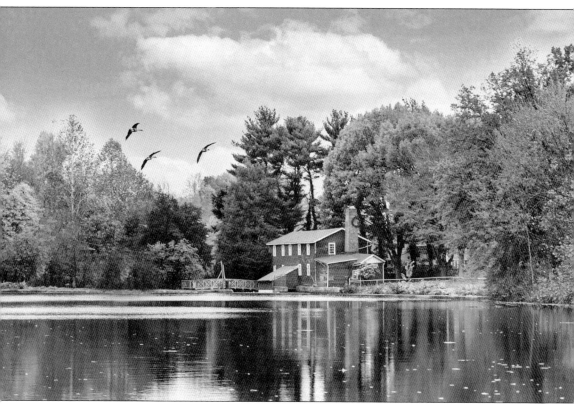

Cooper's Pond—forever tied to the history of Bergenfield—shimmers in this photograph Jen Murray took on an autumn day in 2015. (Photograph by Jen Murray.)

INTRODUCTION

Bergenfield, a bus ride from the bright lights and cacophony of Times Square, is an unpretentious suburb of cozy residential streets; parks, playgrounds, and ball fields; red-brick schools; and small shops lining a narrow main drag named for America's first president. Some 28,000 people reside in this ethnically diverse community, one of the largest in New Jersey's most populous county. But make no mistake: Bergenfield is different from many of its sizable Bergen County neighbors.

Just look around. You will find little industry to speak of. There are no sprawling shopping malls or corporate campuses. No medical centers or universities. High-rises? Those are over in Fort Lee and Hackensack. Highways? You have to drive clear out of town to enter one. Commuter trains? They stopped running decades ago—although the freight trains rumble through several times daily, much to motorists' annoyance.

Bergenfield's most distinctive feature, in fact, may be a pond.

And that leads us back a ways.

Bergenfield's first settlers, in the 17th century, were Dutch immigrants and French Huguenots, and the place was called Schraalenburgh, a Dutch name thought to mean "barren knoll." "The inhabitants of Schraalenburgh were simple folk," Michael J. Birkner wrote in *A Country Place No More*, a scholarly history of the town where he grew up. "Their lives revolved around the sun and the seasons, agricultural labor that yielded bounty to good stewards of the fertile land, and a Calvinist religion emphasizing that there was no moral or economic advantage in pride, avarice, or sloth."

Progress visited this farming area in the mid-19th century when Richard Tunis Cooper, and then his son Tunis Richard Cooper, began building chairs next to what was known as the Mill Pond, a literal stone's throw from the handsome Dutch Reformed church where all worshiped. The chair factory became a leading, albeit fleeting, industry—and the Cooper name would eventually be attached to the pond. The arrival of the railroad changed Schraalenburgh further by making it possible for those living there to work in New York City. In 1894, Schraalenburgh's southern portion was incorporated as a borough with an easily pronounced and modern-sounding name. Bergenfield was on its way.

By the early 1920s, Bergenfield boasted a population of 4,000, a police department, a fire department, multiple schools, a train station, and a growing business community. The fledgling chamber of commerce took a prominent role lobbying for a project miles outside the borough's borders—the construction of a great vehicular bridge across the Hudson River between New Jersey and New York City. The George Washington Bridge opened in 1931, sparking development throughout northern New Jersey, Bergenfield included.

Before long and with great foresight, Bergenfield transformed Cooper's Pond and the land around it into a civic jewel that remains a showplace to this day. The business district started attracting shoppers from afar, thanks in no small measure to a dress shop that its savvy owner built into a beloved department store bearing her name. Bergenfield would gain, at its southern gateway, hundreds of garden apartments and a shopping plaza. Not far behind were a new high school and a new library. A new municipal building would have to wait—it was going up as this book went to press.

Throughout, Bergenfield has remained the quintessential hometown, a place where people put down roots or, when they do move away, look back on with affection. Residents of "The Friendly Town" rally around their first responders, veterans, seniors, youth, merchants, houses of worship, and especially their high school's stellar marching band, an enduring source of pride. As native son and history professor Birkner puts it: "Bergenfield holds on to the small-town-America ethic of pitching in, whether to help families affected by disasters or personal tragedy"—aptly demonstrated during the worst days of the coronavirus pandemic—"or by joining organizations to enhance the community's quality of life."

"Bergenfielders," Birkner says, "love their church bazaars, they support their children's sporting organizations—and they never miss a parade."

Enjoy this pictorial journey through Bergenfield history!

One

From Schraalenburgh to Bergen Fields

Bergen Fields voted on Wednesday 85 to 1 to form a borough.

—The *Bergen County Democrat*, June 29, 1894

The creation of the borough of Bergen Fields—a name soon condensed to "Bergenfield"—merited a dozen words in the *Bergen County Democrat*. In all, 26 boroughs were incorporated in 1894 in Bergen County, a phenomenon known as "boroughitis."

Bergenfield was previously the southern part of the village of Schraalenburgh, itself part of Palisades Township. The northern section of Schraalenburgh would become the borough of Dumont. The West Shore Railroad was responsible for the Bergenfield name—it sent the stationmaster in South Schraalenburgh a die stamp for tickets reading "Bergen Fields," a pleasant name that was less of a mouthful than the old Dutch moniker.

Upon its incorporation, Bergenfield had no paved streets and a population in the hundreds. Its most prominent business—the Cooper chair factory—was no more. Life revolved around South Church. From this bucolic place, a thriving suburb was about to take root.

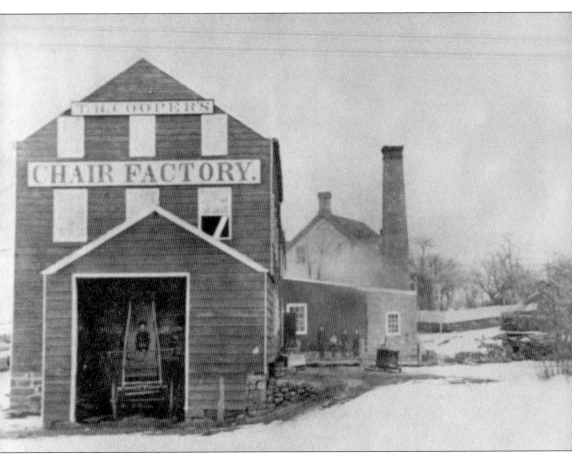

In 1849, ownership of 15 acres of land in Schraalenburgh passed from Richard Tunis Cooper and his wife, Effie, to their son, Tunis Richard Cooper. The site included a frame house, a gristmill, a mill pond, and barns—everything Tunis R. Cooper needed to manufacture chairs. Wood from the forest and rush from the swamp provided raw material; water from the brook flowing into the pond provided power. The business flourished just before and during the Civil War and boasted a New York City showroom and customers as far west as Chicago. For a brief while, T.R. Cooper's Chair Factory made the farming community of Schraalenburgh a hub of industry. (Courtesy of the Bergenfield Museum.)

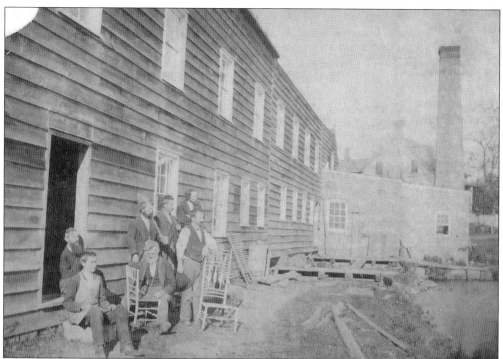

The chair factory's workmen were from the Banta, Earl, Stallwood, and Van Saun families and lived along Prospect Street. Here, workmen gathered on the south side of the factory with cattail- and bamboo-turned chairs, the results of their labor. At its height, the factory employed some 25 men but long-term success was not to be. Business declined after 1863, and the New York City showroom closed. By 1870, Tunis R. Cooper's brother-in-law had taken over management. The factory never revisited its past success, and a devastating fire closed a seminal chapter in Bergenfield history. (Courtesy of the Bergenfield Museum.)

Durability and attention to detail were hallmarks of Cooper chairs, such as this finely carved rocking chair with a cane seat and back. (Courtesy of the Bergenfield Museum.)

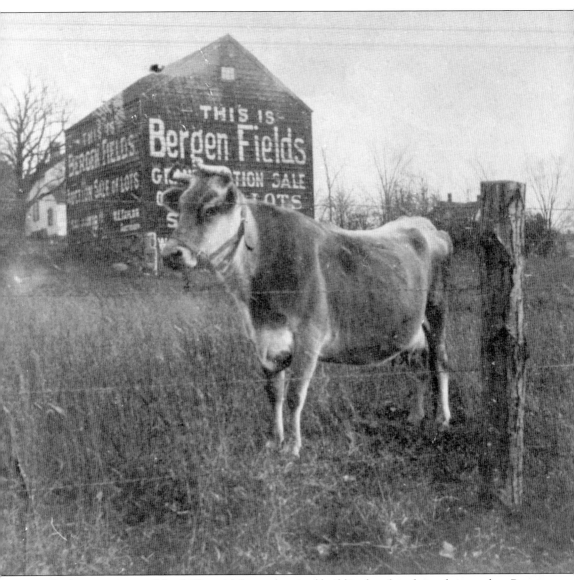

In this iconic image, John J. Christie's barn advertised building lots for sale in what was then Bergen Fields, described by land sellers as "situated on the main line of the West Shore Railroad, 45 minutes from New York." Originally the village of Schraalenburgh, the Bergen County community took on a different name in the 1880s when the railroad issued a dye stamp for tickets reading "Bergen Fields." The post office combined the words and dropped the "s." (Courtesy of the Bergenfield Museum.)

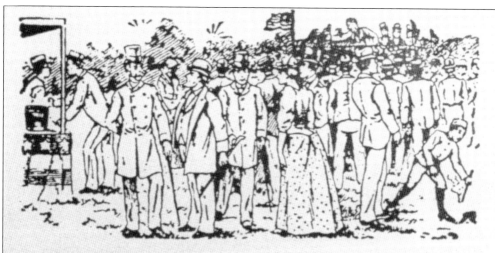

SCENE AT THE LAST BERGEN FIELDS SALE.

WHERE IS

BERGEN FIELDS?

BERGEN FIELDS is situated on the main line of the West Shore Railroad, 45 minutes from New York.

Every Lot is beautifully situated, elevated and sloping, and all of them are high and dry, and close to the depot.

WHAT HAS BERGEN FIELDS ?

Bergen Fields has 22 trains daily (10 on Sunday). Commutation 10 cents. It has Churches, Public and Private Schools, good Stores, Building and Loan Associations, Masonic and Benevolent Associatioes; also Village Improvement and Protective Associations, all near by. TERMS: $10 a Lot down on day of sale.

This advertising flier was for an auction of 127 building lots that real estate man William E. Taylor held on May 18, 1891. The lots were south of Main Street along Summit, William, and Taylor Streets and Woodside Avenue. The growth Bergenfield experienced in the final decade of the 19th century would be dwarfed by the booms of the 20th century. (Courtesy of the Bergenfield Public Library.)

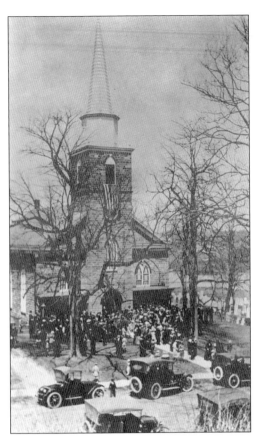

South Presbyterian Church, pictured in 1917, was founded as a Dutch Reformed congregation in 1723. Construction of a small, square-shaped building commenced in 1725 and was completed in 1728. A much larger stone church was erected in 1799. It was called South Schraalenburgh Church, a name that stood until 1913 when the congregation affiliated with the Presbyterian Church. Rev. Garret A. Haring, below, was pastor from 1869 to 1905. (Both, courtesy of South Presbyterian Church.)

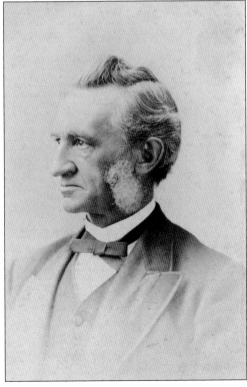

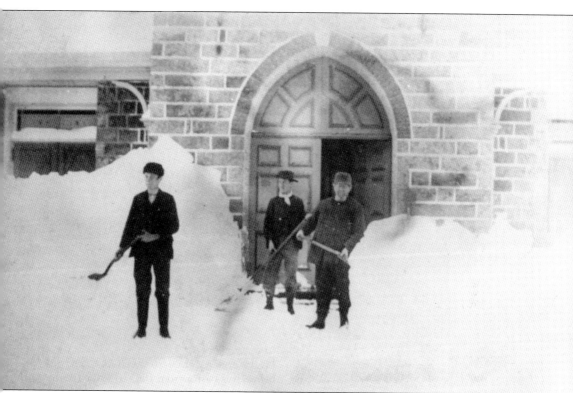

From left to right, Will Stallwood, George Stallwood, and James Vreeland shoveled a path to the entrance of South Schraalenburgh Church after the Great Blizzard of March 1888. (Courtesy of the Bergenfield Museum.)

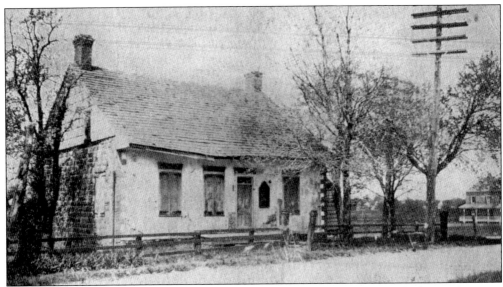

This stone house stood at the southwest corner of Washington Avenue and Clinton Avenue—present-day site of Roy W. Brown Middle School—from the late 1700s to the early 1900s. An 1811 map showing Schraalenburgh labeled the building as a tavern. (Courtesy of the Berdan collection.)

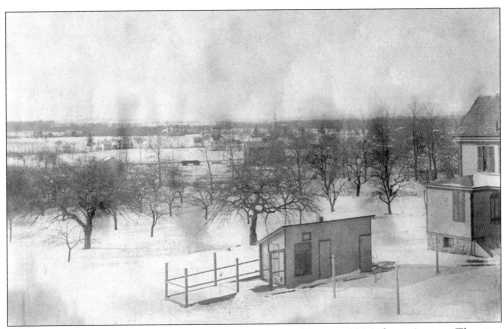

Jacob H. Adriance took this photograph in 1902 from his house at 70 Madison Avenue. The view is looking northwest. Just beyond the orchard in the foreground is Washington Avenue, before it was a commercial artery. The building at center is the J.Z. Demarest coal storage facility; a railroad car is to the left. South Church's steeple is visible in the distance. (Courtesy of Tim Adriance.)

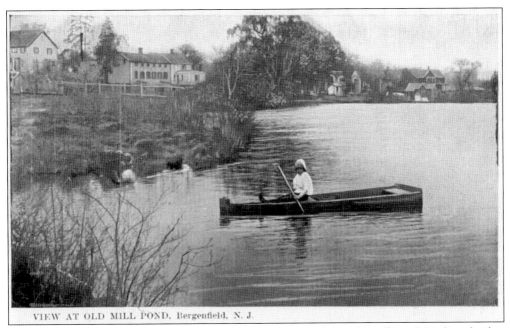

VIEW AT OLD MILL POND, Bergenfield, N. J.

What residents know today as Cooper's Pond used to be called the Old Mill Pond. Back in the day, boating was permissible and ice skaters would descend on the pond when the water was sufficiently frozen. (Courtesy of the Berdan collection.)

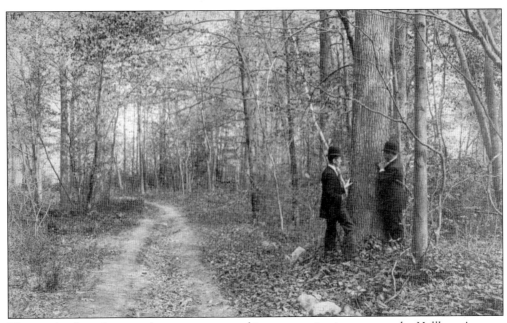

The woods where these gentlemen were engaged in conversation is at present-day Hallberg Avenue, near the New Milford border. In 1911, Carl Hallberg purchased the acreage between the border and Prospect Avenue for residential development. (Courtesy of Michael J. Birkner.)

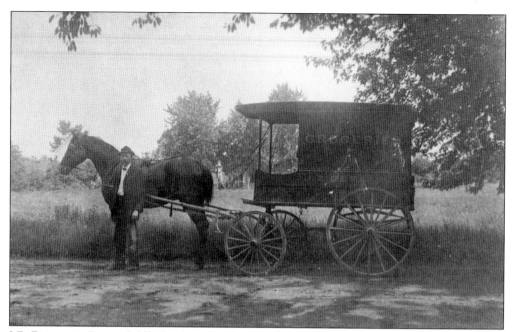

J.Z. Demarest, Bergenfield's first merchant, opened a general store in 1884. His business sold hay, lumber, canned goods, coal, and the like. It also served as the post office and boasted the community's first telephone. (Courtesy of the Bergenfield Museum.)

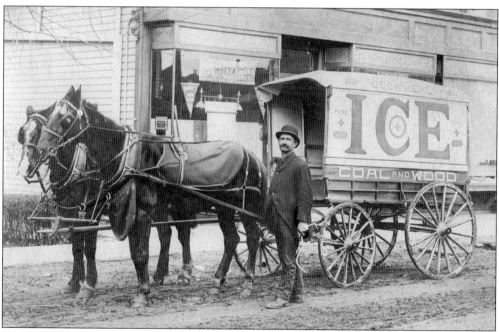

Jacob Kherbackian, junk dealer and ice seller, was a familiar man about town. "Go to Jake for ice, to keep everything nice!" he advertised. The Armenian immigrant had a keen interest in civic affairs and religiously attended meetings of the mayor and council. "Frequently he was the only person except newspaper reporters attending many of the community's important meetings," the *Bergen Evening Record* wrote in his 1947 obituary. (Courtesy of the Bergenfield Museum.)

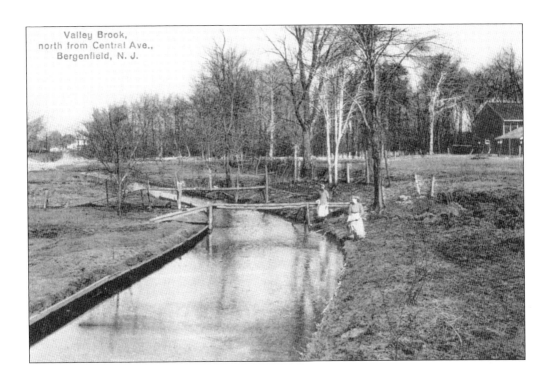

Valley Brook,
north from Central Ave.,
Bergenfield, N. J.

These postcard scenes from early Bergenfield show, above, a peaceful stream (today called Hirschfeld Brook) in the borough's northwest corner and, below, the horticultural nursery—at the site of the present-day Staples store and municipal building—where Thomas W. Head grew chrysanthemums, carnations, and dahlias. (Both, courtesy of the Berdan collection.)

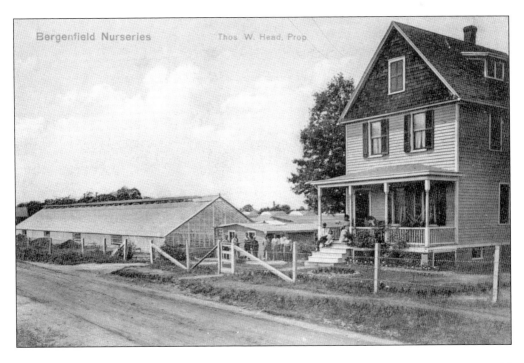

Bergenfield Nurseries Thos. W. Head, Prop.

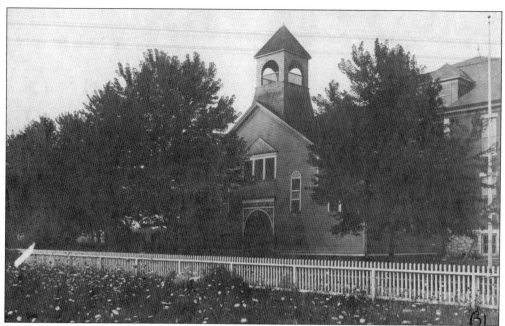

Friction between residents of southern Schraalenburgh (known as Bergen Fields) and northern Schraalenburgh (the future Dumont) led to Bergen Fields creating a separate school district and in 1891 building this two-story frame school in an empty field. Note the tower, which contained a bell operated by a rope. This original Bergenfield school stood until Washington School was constructed at its very spot in 1905. The photograph above shows both school buildings before the original was torn down. (Both, courtesy of the Bergenfield Museum.)

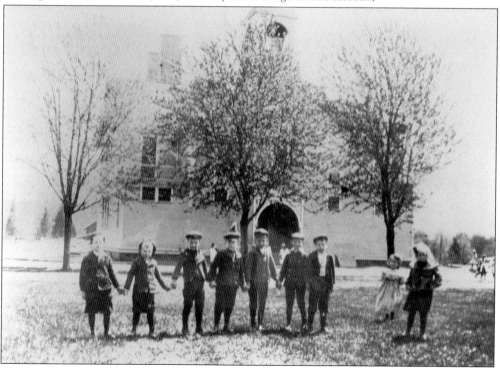

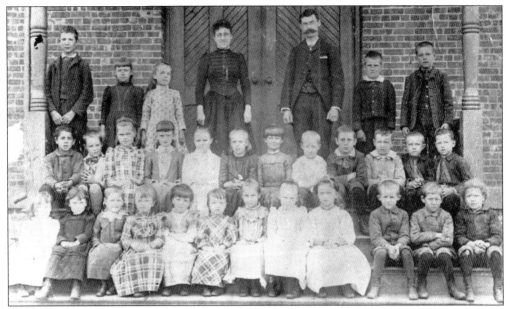

James Coe, the principal, taught the upper grades and Maggie Demarest taught the lower grades in Bergenfield's original school. Here, the two educators joined students for a school picture. Maggie Demarest, in particular, was a formidable presence. "A stern disciplinarian by simple force of character, she never for a moment during several decades of teaching in Schraalenburgh and Bergenfield let down the wall that separated teacher and student," Adrian C. Leiby wrote in *The Huguenot Settlement of Schraalenburgh: The History of Bergenfield, New Jersey.* (Courtesy of the Bergenfield Museum.)

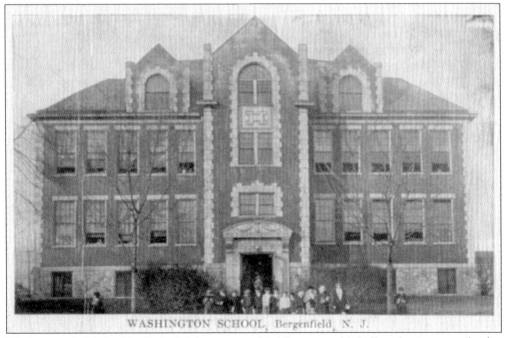

WASHINGTON SCHOOL, Bergenfield, N. J.

Washington School originally had eight rooms, a third-floor assembly hall, and a six-person faculty. It was built in 1905 at a cost of $25,000. (Courtesy of the Berdan collection.)

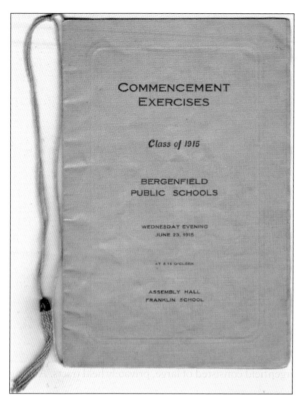

COMMENCEMENT
EXERCISES

Class of 1915

BERGENFIELD
PUBLIC SCHOOLS

WEDNESDAY EVENING
JUNE 23, 1915

AT 8:15 O'CLOCK

ASSEMBLY HALL
FRANKLIN SCHOOL

In the latter half of the 20th century's second decade, Bergenfield had two schools, Washington and Franklin, serving a population of about 3,000. Here are the covers of the school system's commencement programs for 1915 and 1919. The ceremony shifted from the Franklin School assembly hall to the much larger Palace Theatre, suggesting a rise in enrollment over the four-year period. (Both, courtesy of Anthony Marsilio.)

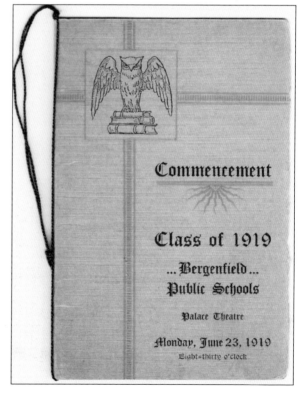

Commencement

Class of 1919

...Bergenfield...
Public Schools

Palace Theatre

Monday, June 23, 1919
Eight-thirty o'clock

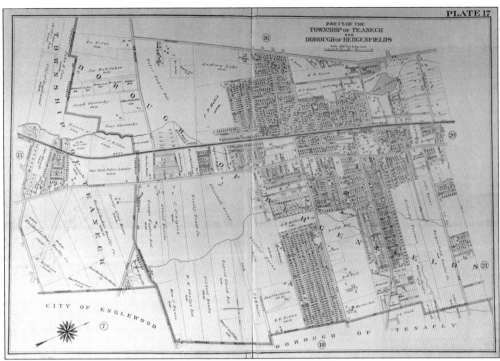

PLATE 17

PARTS OF THE
TOWNSHIP OF TEANECK
AND
BOROUGH OF BERGENFIELDS

This 1912 map shows that about half of Bergenfield consisted of large, privately held tracts. Among the more prominent landholders were Walter Christie, William P. Tyson, and the estate of George Foster. Interestingly, Bergenfield is misidentified as "Bergenfields"—a throwback to the community's short-lived 19th-century name. (Courtesy of the Bergenfield Public Library.)

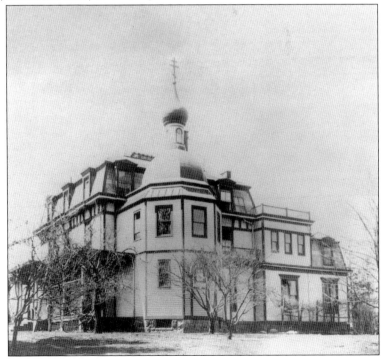

For several years, the Russian Orthodox Church operated a seminary at this property on the Bergenfield-Tenafly border. The students helped sustain St. Platon's Seminary by raising crops. Most of the support, however, came directly from Russia. The seminary fell on hard times as a result of the 1917 Russian Revolution and closed a short time later. (Courtesy of the Bergenfield Museum.)

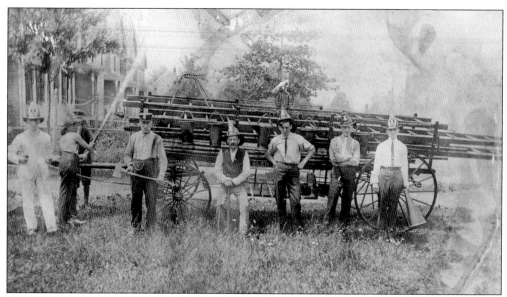

Alert Fire Company No. 1's formation in 1904 gave rise to an organized system of volunteer fire protection in Bergenfield. The company obtained a horse-drawn hook-and-ladder truck from neighboring Tenafly; the borough provided the first motorized apparatus in 1917. The photograph above shows "the Alerts" in front of their horse-drawn truck in 1909; below, the men were joined by fellow firefighter and mayor, Thomas J. Prime, wearing business attire, in 1919. That year, the Alerts and the borough's two other fire companies were merged into a single fire department. (Above, courtesy of the Bergenfield Public Library; below, courtesy of Eva Gallione.)

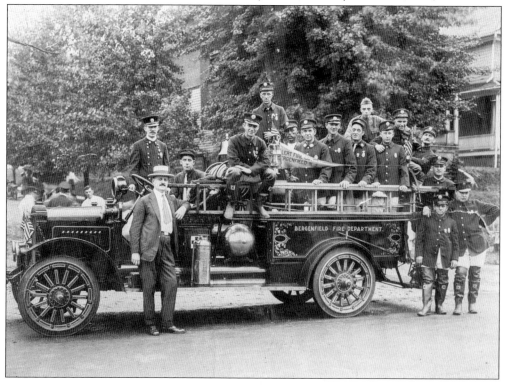

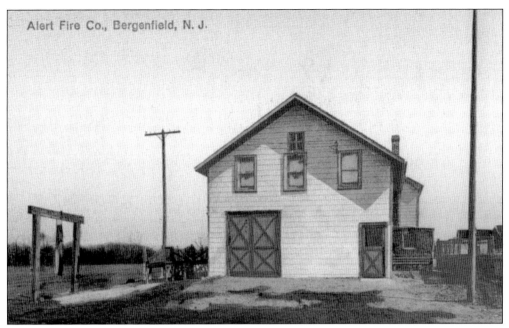

Alert Fire Co., Bergenfield, N. J.

The postcard above shows the Alert Fire Company's first headquarters, a barn on Bradley Avenue. Below, the men of Bergenfield's three fire companies pose on the nation's 147th birthday—July 4, 1923—during the Firemen's Day celebration. The companies competed in contests such as hose laying and ladder climbing. (Above, courtesy of the Berdan collection; below, courtesy of the Bergenfield Museum.)

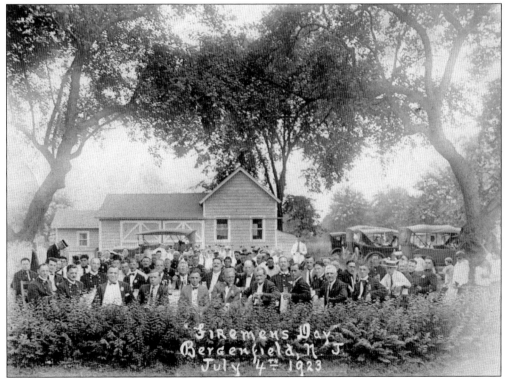

"Firemens Day"
Bergenfield, N. J.
July 4th 1923

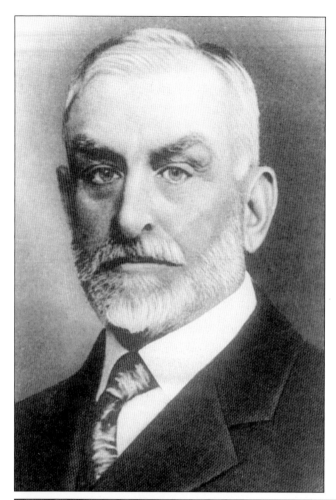

Walter Christie—Bergenfield's "Town Father"—descended from one of the oldest families in northern New Jersey. Born in 1863, Christie was politically active in Palisades Township and spearheaded Bergen Fields' breakaway. He was elected to the first borough council and subsequently served as mayor, school board president, and Bergen County freeholder. He also was a force in banking. Below, Christie and his wife, Maria (Van Wagoner) Christie, were among the first people in Bergenfield to own an automobile. (Left, courtesy of the Bergenfield Museum; below, courtesy of the Bergenfield Public Library.)

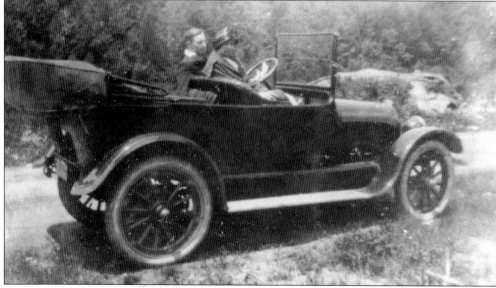

Dr. George Pitkin arrived in Bergenfield around 1910 and practiced medicine for three decades while assuming prominent roles in civic and business affairs. He resided in this Victorian home at Washington Avenue and Main Street, in the spot later occupied by Woolworth's. A specialist in spinal anesthesia, Pitkin helped found Holy Name Hospital in Teaneck. In 1943, while performing surgery, his appendix ruptured; he completed the procedure and died three days later, at age 58. (Right, courtesy of the Bergenfield Museum; below, courtesy of the Berdan collection.)

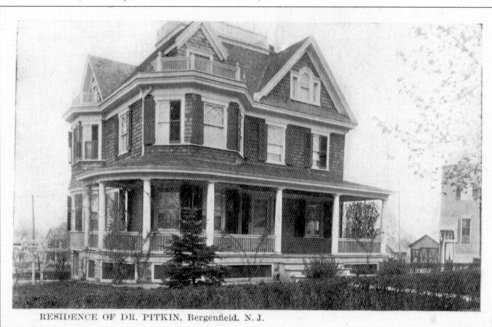

RESIDENCE OF DR. PITKIN, Bergenfield, N. J.

27

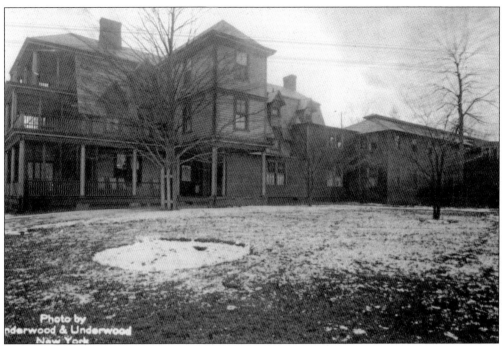

Camp Merritt, an Army staging area for soldiers bound for European battlefields in the First World War, sprawled over 770 acres in several Bergen County towns. Among the facilities within the Bergenfield limits were the home of Ella R. Berry, above, used as a nurses' quarters, and the base hospital isolation ward, below, where soldiers with contagious diseases were treated. The latter presumably was filled during the influenza pandemic of 1918, which claimed the lives of 578 soldiers, nurses, and civilians at Camp Merritt. (Both, courtesy of Howard E. Bartholf.)

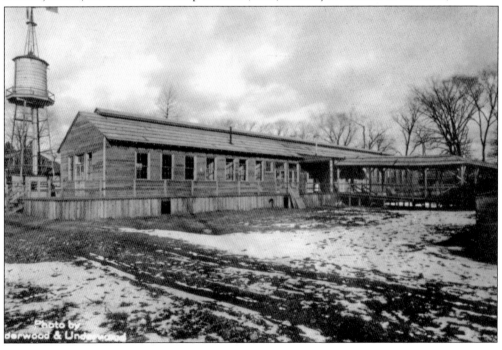

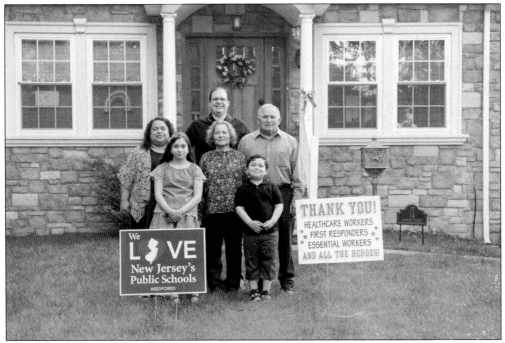

The previous page represents the 1918 influenza pandemic. The photographs here are from 2020, when Americans isolated at home as a result of the coronavirus pandemic. Jen Murray photographed Bergenfield families in the months before COVID-19 vaccines were developed. Her Bergenfield Front Porch Project chronicled a difficult time and raised funds for the Volunteer Ambulance Corps. As of December 2022, COVID-19 was responsible for the deaths of 76 borough residents. (Both photographs by Jen Murray.)

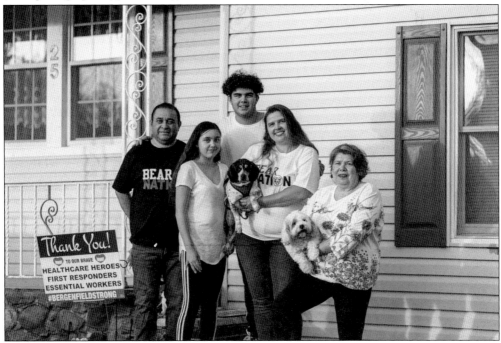

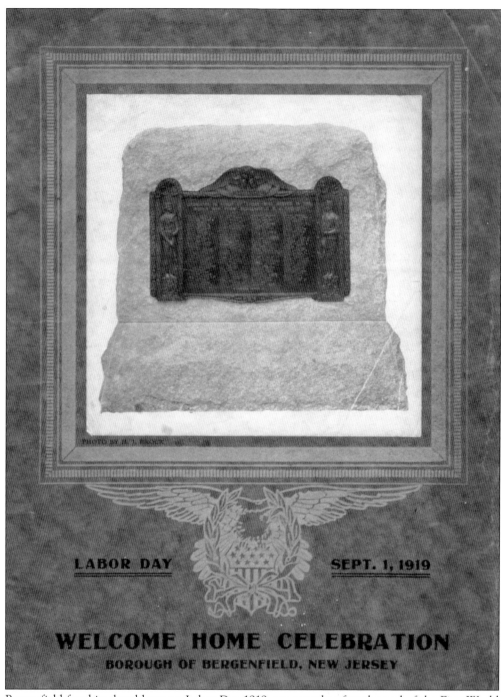

LABOR DAY SEPT. 1, 1919

WELCOME HOME CELEBRATION
BOROUGH OF BERGENFIELD, NEW JERSEY

Bergenfield feted its doughboys on Labor Day 1919, ten months after the end of the First World War. A welcome home celebration featured a parade, dinner served by "a committee of young ladies," and a reception and dance at the Palace Theatre. The day's program cover included a photograph of a plaque bearing the names of all those from Bergenfield who fought in the war. An asterisk marked the name of Edward J. Anderson, the only one killed in service. (Courtesy of the Bergenfield Public Library.)

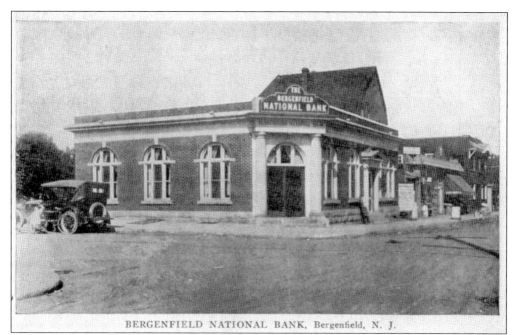

BERGENFIELD NATIONAL BANK, Bergenfield, N. J.

Bergenfield National Bank, across from the train station, was chartered in 1919, with Walter Christie serving as president. The original building, at West Main Street and North Front Street, still stands. The Bergenfield National name lasted until the early 1960s, when the institution merged with Citizens National Bank. (Courtesy of the Berdan collection.)

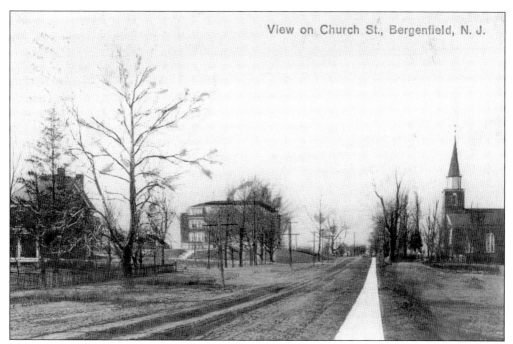

View on Church St., Bergenfield, N. J.

This postcard shows a pastoral West Church Street. At right is South Church, and at center is Franklin School. (Courtesy of the Berdan collection.)

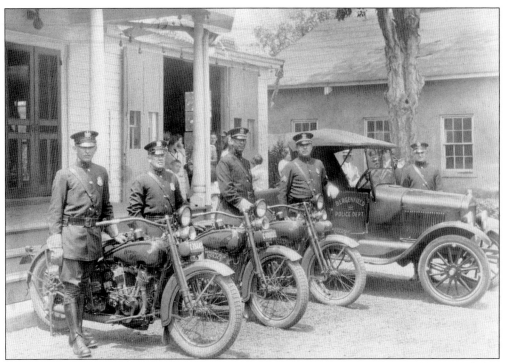

Before the police department was formed on March 9, 1921, Bergenfield was protected by plainclothes marshals who were paid only when called to duty. The department acquired its first car, a Model T Ford, in 1923. Above, officers posed with their motorized fleet outside borough hall in 1926; below, department members stood at attention in 1930. (Above, courtesy of the Bergenfield Museum; below, courtesy of the Bergenfield Public Library.)

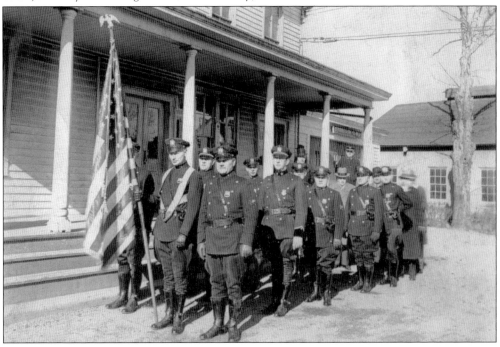

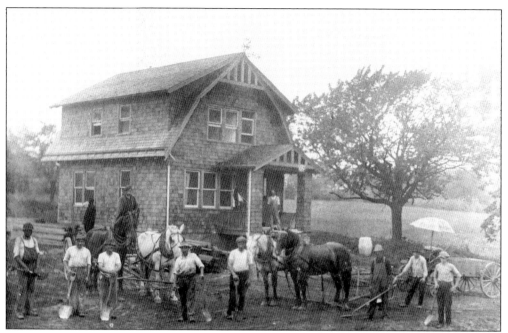

Haring Street is a residential block south of Cooper's Pond, but in 1914, the Haring Street home of John Huyler—No. 44—stood alone. In *The Huguenot Settlement of Schraalenburgh: The History of Bergenfield, New Jersey*, author Adrian C. Leiby described John Huyler as a house painter known for his fine workmanship—and chronic tardiness. (Courtesy of the Bergenfield Museum.)

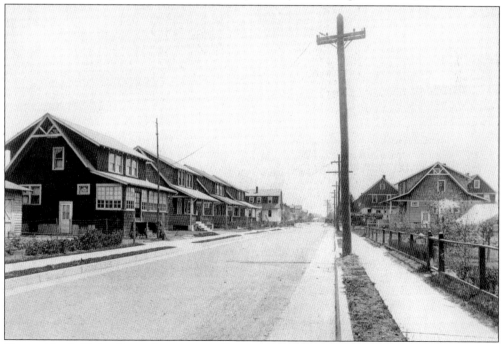

Here is North Taylor Street, between Bradley Avenue and East Main Street, around 1915. This style of Colonial home was popular with developers of that era. The trees would be planted later. (Courtesy of the Bergenfield Museum.)

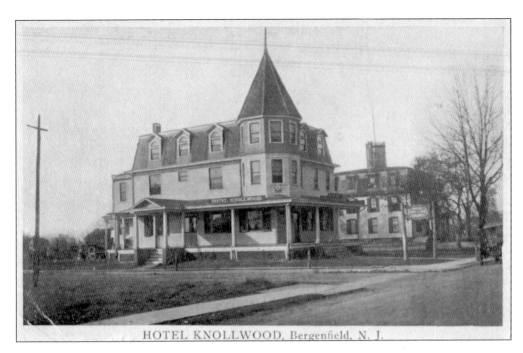

HOTEL KNOLLWOOD, Bergenfield, N. J.

Above, the Knollwood Hotel on North Washington Avenue was a place for hospitality and drink. Maybe too much drink—its barroom was raided and the bartender arrested on August 7, 1929, ten years into Prohibition. The building next door, visible at right in the postcard above, served as borough hall, seen below, from 1920 to 1936. (Both, courtesy of the Berdan collection.)

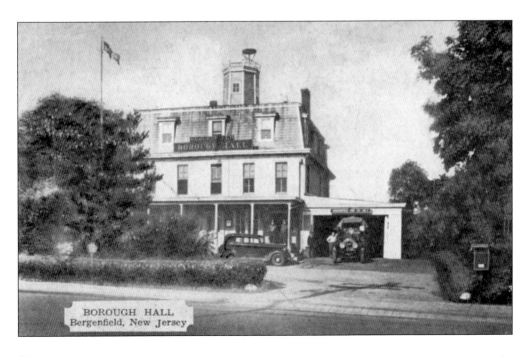

BOROUGH HALL
Bergenfield, New Jersey

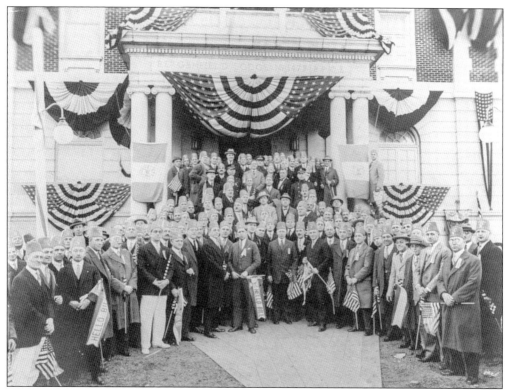

Bergenfield Elks Lodge No. 1477 was organized in 1923 and a handsome headquarters built at 198 North Washington Avenue, the backdrop for the portrait above. Unfortunately, the Elks experienced financial misfortune during the Depression and were forced to seek smaller quarters. In 1936, the grand lodge became Bergenfield's municipal building, below. (Above, courtesy of Elks Lodge No. 1477; below, courtesy of the Berdan collection.)

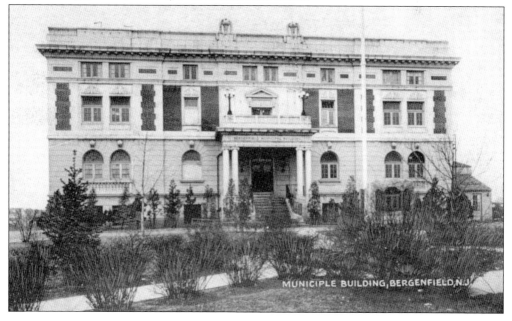

MUNICIPLE BUILDING, BERGENFIELD, N.J.

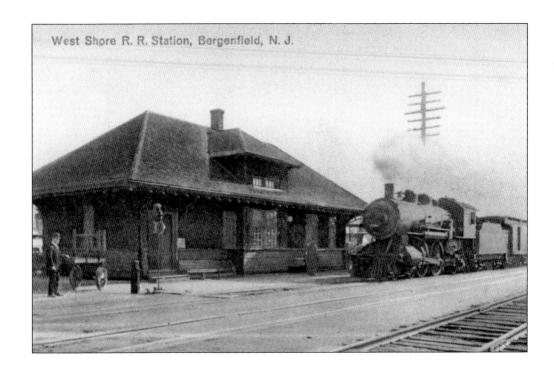

West Shore R. R. Station, Bergenfield, N. J.

For some 75 years, many who worked in New York City began and ended their daily commutes at the Bergenfield train station on the West Shore line of the New York Central Railroad. Passengers rode south to Weehawken and transferred to a Hudson River ferry. Commuter service ended in 1958, leaving the bus as the only mass transportation option. (Both, courtesy of the Berdan collection.)

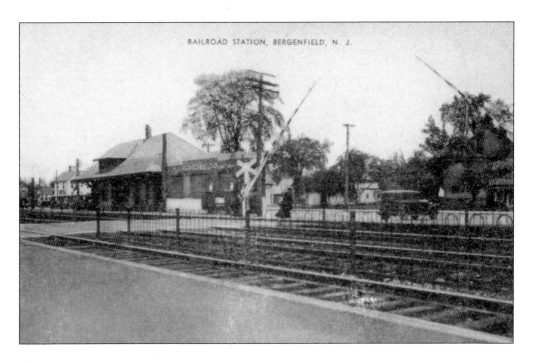

RAILROAD STATION, BERGENFIELD, N. J.

BERGENFIELD

These listings contain the names of men and women adults only

A

Abbatanti, Nicholas, *laborer*193 Porter av
Abbatanti, Mrs. Nicholas193 Porter av
Abbatiello, Pasquale, *tailor*70 Roosevelt av
Abbatiello, Mrs. Pasquale70 Roosevelt av
Abbatiello, Salvatore, *plasterer*....70 Roosevelt av
*Abel, Alexander, *carpenter*84 Ralph st
Abel, Mrs. Alexander84 Ralph st
Abel, Helen84 Ralph st
*Abel, John F., *office manager*....73 Madison av
Abel, Mrs. John F.73 Madison av
Abrams, Gus, *carpenter*63 Phelps av
Abrams, Mrs. Gus63 Phelps av
Abrandt, Wm., *mechanic* ..107 N. Washington av
Abrandt, Mrs. Wm.107 N. Washington av
Abrahamson, Julius, *fireman*.......140 Phelps av
Abrahamson, Mrs. Julius140 Phelps av
*Abt, Raymond V., *garage owner*,
 210 S. Washington av
Abt, Mrs. Raymond V.....210 S. Washington av
*Ackerman, Otto L., *bakery and lunch room*,
 54 S. Washington av
Ackerman, Mrs. Otto L.....54 S. Washington av
*Adams, Andrew, *driver*36 Hickory av
Adams, Mrs. Andrew36 Hickory av
*Adriance, Carrie, *widow*70 Madison av
*Adriance, Percy F., *plumber*......86 E. Main st
Adriance, Mrs. Percy F.86 E. Main st
*Adriance, Walton D., *clerk*10 E. Broad st
Adriance, Mrs. W. D.10 E. Broad st
*Aemisegger, Jean, *designer* ..26 S. Demarest av
Aemisseger, Mrs. Jean26 S. Demarest av
Aho, Klaus, *electrician*57 Haring st
 c/o Brothers
*Alanzer, Fredric, *piano tuner*..92 S. Demarest av
 c/o Farrell
Albert, Rudolph85 N. Summit st
Albert, Mrs. Rudolph85 N. Summit st
Albertanti, Thos., *laborer*99 Palisade av
Albertanti, Mrs. Thos.99 Palisade av
Alderton, Wm.38 Smith av
Alderton, Mrs. Wm.38 Smith av
*Alexander, Raymond W., *insurance broker*,
 17 Edward st
Alexander, Mrs. Raymond W.......17 Edward st
*Algor, Robert F., *clerk*38 E. Clinton av
Algor, Mrs. Robert F.38 E. Clinton av
 c/o Folker
*Allegro, Nick, *pad maker* ..456 S. Washington av
Allegro, Mrs. N.456 S. Washington av
*Allen, Mrs. Anna69 W. Central av
 c/o Connor
*Allen, Walter, *realtor*19 Carlisle st
Allen, Mrs. Walter19 Carlisle st
*Alt, Charles T., *manager*80 Haring st
Alt, Mrs. Charles T.80 Haring st
*Ames, LaVerne F., *mason*26 Roosevelt av
Ames, Mrs. LaVerne F.26 Roosevelt av
Ames, Walter R., *salesman*26 Roosevelt av
Ammon, Lena C., *stenographer*....65 W. Main st
*Anders, Otto, *retired*64 Phelps av
Anders, Mrs. Otto64 Phelps av
Anders, Frederick, *accountant*..49 E. Johnson av

Anders, Mrs. Frederick49 E. Johnson av
*Anderson, Alfred, *painter*25 Tuscarora st
Anderson, Mrs. Alfred25 Tuscarora st
*Anderson, Axel33 Murray Hill ter
Anderson, Mrs. A.33 Murray Hill ter
Anderson, Lillian, *secretary*....33 Murray Hill ter
Anders, Charles H., *canvasser*......43 Haring st
Anders, Mrs. Charles H.43 Haring st
*Anderson, Albert, *mechanic* ..148 N. Prospect av
Anderson, Mrs. Albert148 N. Prospect av
 c/o Leimbach
*Anderson, Eric, *contractor*........72 Bradley av
Anderson, Mrs. Eric72 Bradley av
Anderson, Henry, *carpenter*109 Bergen av
Anderson, Mrs. H.109 Bergen av
Anderson, Theodore, *carpenter*..41 W. Church st
Anderson, Mrs. Theodore41 W. Church st
Andre, Mrs. Lena, *widow*16 N. Demarest av
*Andre, A., *butcher*31 Irvin pl
Andre, Mrs. A.31 Irvin pl
Andrews, Harry, *contractor*63 Terrace av
Andrews, Mrs. Lenore63 Terrace av
*Andrews, Margaret, *widow*,
 147 S. Washington av
Andrews, Wm., *newsdealer*..147 S. Washington av
Andrews, Miss Hannah, *secretary*,
 147 S. Washington av
Andrews, Thos., *accountant*.147 S. Washington av
Angersbach, Annie, *housekeeper*..13 S. Summit st
Angersbach, Minnie, *operator*13 S. Summit st
Annunziato, Anthony, *fur dresser*..44 Hickory av
Annunziato, Mrs. Anthony44 Hickory av
*Anstatt, Herman E., *auditor*....39 E. Church st
Anstatt, Mrs. Herman E.39 E. Church st
Anthony, Wm., *cesspool builder*....30 Delford av
Anthony, Mrs. Wm.30 Delford av
*Appeleby, Bertram29 Bergen av
Appeleby, Mrs. Bertram29 Bergen av
 c/o Lober
Archer, David, *printer*68 Delford av
Archer, Mrs. David68 Delford av
Archer, Thomas, *checker*68 Delford av
Archer, Mrs. Elizabeth, *widow*....148 Merritt av
*Archer, Herbert J., *steamfitter*,
 142 W. Central av
Archer, Mrs. Mary C.142 W. Central av
Arthur, Thomas J., *chauffeur*..........27 Elm st
Arthur, Mrs. Thomas J.27 Elm st
Aschenbrand, Joseph, *painter*....102 W. Broad st
Aschenbrand, Mrs. Joseph102 W. Broad st
Aschenbrand, Bernhard, *clerk*....102 W. Broad st
Aschenbrand, Walter, *confectioner*,
 102 W. Broad st
*Asplint, Chas., *master plumber*....33 Bergen av
Asplint, Mrs. Chas.33 Bergen av
*Asselta, Michael, *porter*...456 S. Washington av
Asselta, Mrs. Michael.......456 S. Washington av
Asselta, Michael, Jr.......456 S. Washington av
Atkins, John B., *salesman*74 W. Main st
Atkins, Mrs. John B.74 W. Main st
Auslander, Jos., *electrician*Luke av
Auslander, Mrs. Jos.Luke av
*Austin, Charles, *crew dispatcher* 56 Porter av
 c/o Hillman

Designates Telephone Connection

Think of the 1926 Twinboro directory as a telephone book without telephone numbers. "Twinboro" refers to Bergenfield and Dumont—the two boroughs that used to be Schraalenburgh. Here is the first page of the Bergenfield listings. Note the occupations of some of the residents: cesspool builder, fur dresser, pad maker. (Courtesy of the Bergenfield Public Library.)

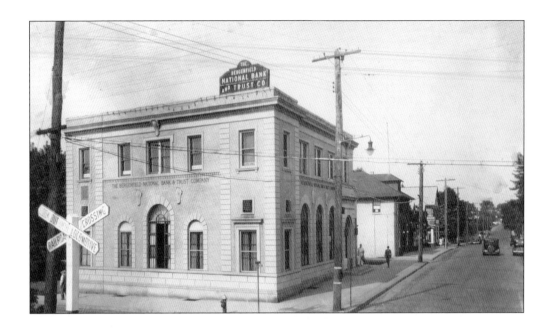

West Main Street was Bergenfield's main thoroughfare before the commercial development of Washington Avenue. Here are two views, almost a century apart, of West Main Street looking west. These days, the railroad crossing arms are lowered only for freight trains. (Above, courtesy of the Bergenfield Public Library; below, photograph by Jen Murray.)

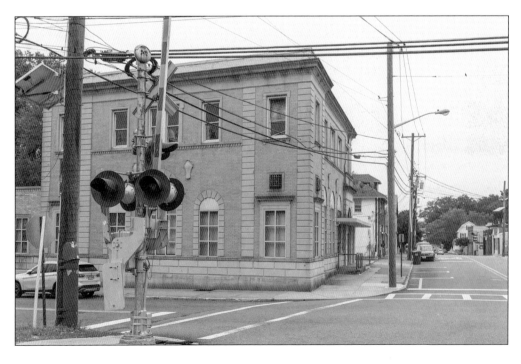

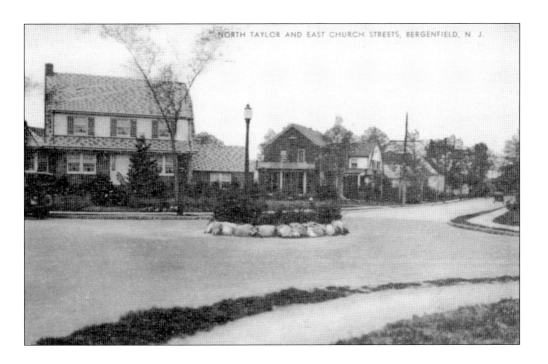

In a state known for traffic circles, Bergenfield has just one. This minuscule landmark at the intersection of East Church Street and North Taylor Street is as well tended today as it was in the 1920s. (Above, courtesy of the Berdan collection; below, photograph by Jen Murray.)

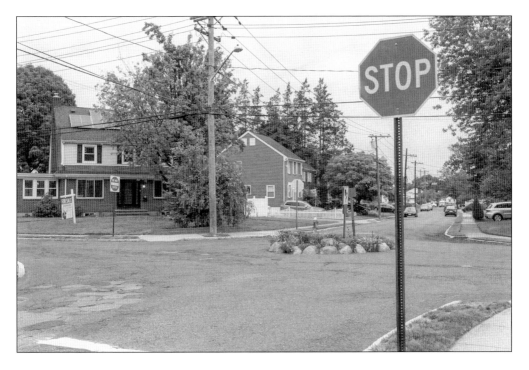

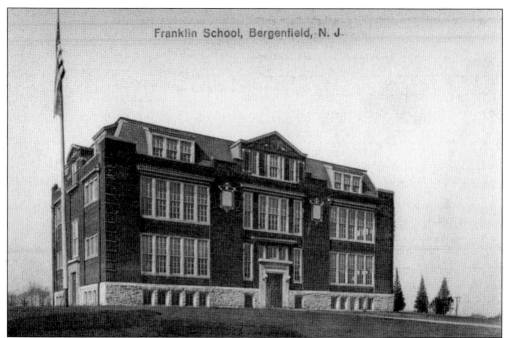

Franklin School, Bergenfield, N. J.

Built in 1909, Franklin School was the architectural duplicate of Washington School. Below, one-fifth of the Franklin student body performed in a play. Enrollment skyrocketed in the 1920s; nearly 60 new students enrolled in the fall of 1923 alone because of rampant homebuilding. Overcrowding was alleviated when Harding School opened its doors. (Above, courtesy of the Berdan collection; below, courtesy of the Bergenfield Museum.)

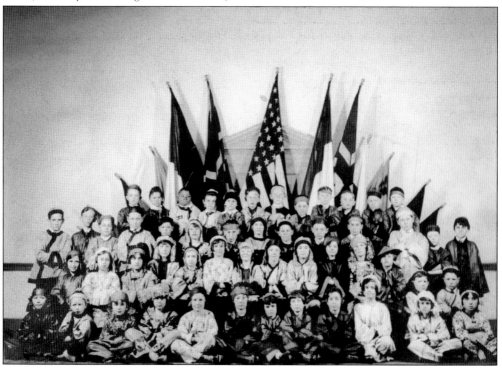

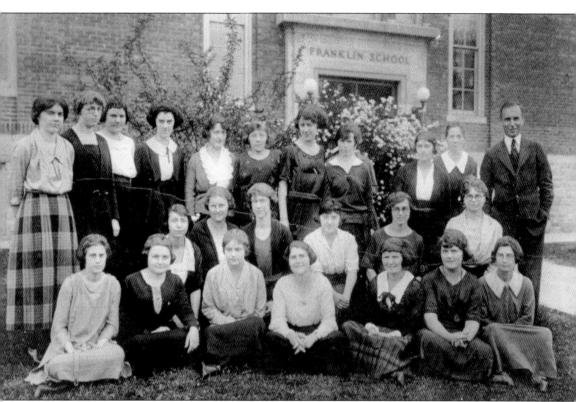

This Franklin School faculty portrait, c. 1920, is notable for the inclusion of Roy W. Brown, far right, who had supervisory duties there and at Washington School. During the 37 years he headed the Bergenfield school district, four elementary schools were constructed and a junior-senior high school was established, in a building that today bears his name. (Courtesy of the Bergenfield Museum.)

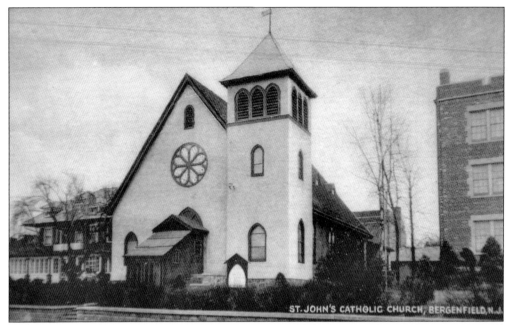

St. John the Evangelist Roman Catholic Church was established in 1905 by two dozen Bergenfield and Dumont families. The first two years, gatherings were held in the South Washington Avenue home of Mr. and Mrs. Edward Flood and in a public hall. Twelve lots on North Washington Avenue were purchased for the construction of the church building seen here; the cornerstone was laid on March 3, 1907. A rectory and a school followed. The congregation grew along with Bergenfield, necessitating a larger church. (Courtesy of the Berdan collection.)

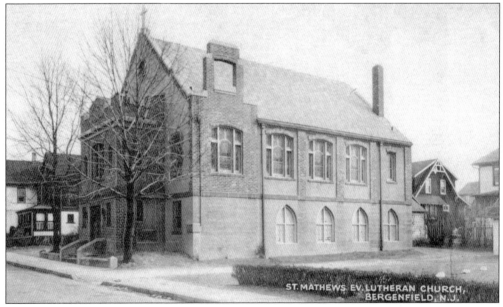

St. Matthew's Evangelical Lutheran Church traces its roots to May 3, 1908, when the first services were held at Concordia Hall in Dumont, under the name Trinity German Evangelical Church. The congregation incorporated as St. Matthew's in 1910, and its church building on Tuscarora Street was dedicated on February 5, 1928. (Courtesy of the Berdan collection.)

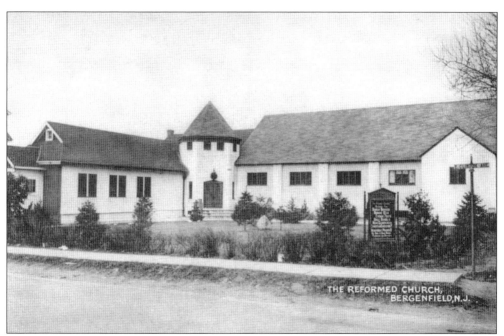

The Reformed Church was organized in 1923 and its chapel constructed on a plot of land acquired at the northwest corner of Clinton Avenue and James Street. Harry A. Olson was the first full-time pastor, ministering to 86 charter members. What became known as Clinton Avenue Reformed Church was replaced by a new building and school in 1958. (Courtesy of the Berdan collection.)

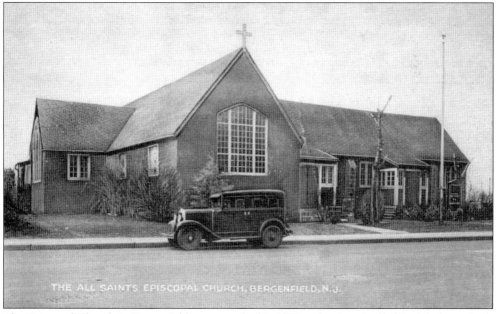

The Episcopal Church in Bergenfield was organized in 1893 and a chapel called St. John's was built at the corner of Summit and Main Streets in 1907. The congregation joined with an Episcopal Mission from Dumont called All Saints a decade later; the merged organization took the All Saints name. The congregation purchased property at North Washington and West Central Avenues, and the church was moved to that site on timber rollers. (Courtesy of the Berdan collection.)

COLLECTOR'S TAX NOTICE

1924

Borough of Bergenfield

HARRY B. INMAN, Collector.

Telephone 665 Dumont

RATE IN DETAIL Per $100 Valuation		
State Road1008	$4,991.50
State School ..	.2551	12,636.94
Soldiers' Bonus Bond0217	1,073.43
State Bridge and Tunnel ..	.0205	1,011.58
State Hospital.	.0500	2,477.18
County Tax .9057		44,870.20
District Court....	.0050	244.62
Local Tax 1.1612		58,123.60
Local School ..1.6200		80,260.00
Total 4.1400		$205,689.05
Less Bank Stock Tax		627.95
Net taxes to be raised		$205,061.10

The Collector will receive taxes only at the Borough Hall, on Tuesday and Thursday evenings, from 8 to 10 P. M. During July, August and September, on Tuesday evenings only.

Remittance may be made by mail at any time; make check, draft or money-order payable to H. B. Inman, Collector.

Discount of 6% allowed on first half of tax if paid on or before May 2 and on second half if paid on or before November 2.

Penalty of 8% charged on all delinquent taxes figured in exact days.

Any appeal from this bill must be made and sworn to on blanks furnished by the Bergen County Board of Taxation, and such copy filed with the County Board of Hackensack, and duplicate filed with the Municipal Clerk or Attorney, and these appeals must be filed on or before June 15th, 1924.

Appeal blanks can be procured from your Tax Collector or County Board of Taxation, Hackensack, N. J.

MR. *Harry B Sugden*
Bergen ave.

Page *190* Line *5* Block *270* Lot *137-144* No. Lots *8* No. Acres

VALUATIONS			RATE 4.14 PER $100 VALUATION							
				Amount of Tax		1st Half of Tax Due June 1st		2d Half of Tax Due Dec. 1st		
				Dollars	Cts.	Dollars	Cts.	Dollars	Cts.	
Value of Land	$	3 0 0 0	Real and Personal	211	14					
Value of Buildings	$	2 0 0 0	Poll Tax	1	—					
Value of Personal Property	$	2 0 0	Postage							
Value of Automobiles	$		Interest	14	62					
Total Value or Real and Personal	$	5 2 0 0								
Deductions and Exemptions	$	1 0 0								
Net Valuation	$	5 1 0 0	Total	212 14						

1st Half Rec'd Payment 192..

.................................... Collector.

2d Half Rec'd Payment *all 7/31/25* 192..

J. M. Villey Col. Collector.

This statement shows Bergen Avenue homeowner Harry B. Sugden owed $212.14 in property taxes in 1924. Nowadays, the typical Bergenfield homeowner pays more than $10,000 annually in property taxes. (Courtesy of the Bergenfield Museum.)

Francesco and Maria Grazia
Di Maggio settled in Bergenfield
after emigrating from Italy around
1904 and ran a Merritt Avenue sweet
shop for many years. The market,
above, sold candy, ice cream, and
essentials. The Di Maggios raised
seven children, including Ferdinand
and Antoinette, at right. (Above,
courtesy of Grace Di Maggio Kanapich;
right, courtesy of Eva Gallione.)

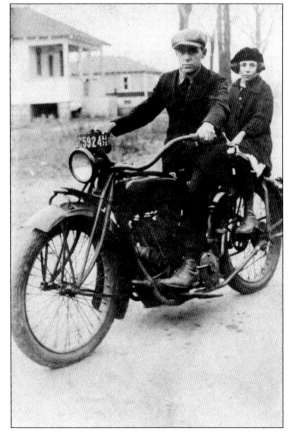

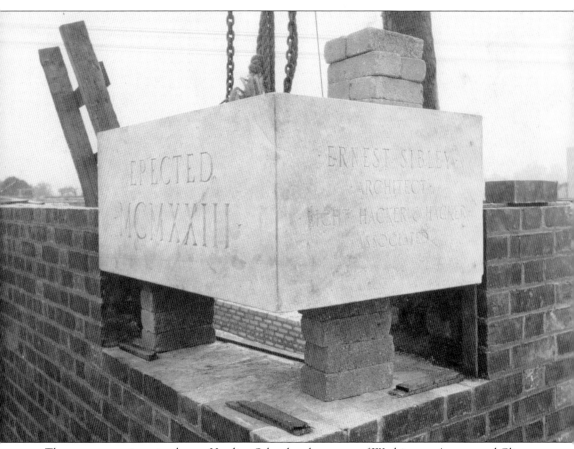

The cornerstone is set in place at Harding School at the corner of Washington Avenue and Clinton Avenue. Completed in 1923 and named for Pres. Warren G. Harding, who had just passed away, Harding was the third school constructed after the borough's incorporation. Its auditorium became a popular venue for cultural, political, and civic meetings. (Courtesy of the Bergenfield Public Library.)

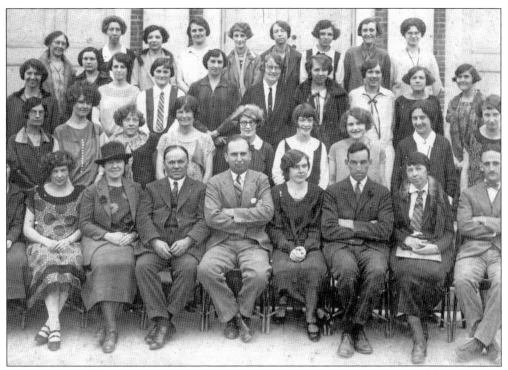

Above, the Harding School faculty stood for a portrait; below, the class of 1931 posed at graduation. Many of these students likely did not continue with their education because of the Depression; those who did attended class in Dumont, Tenafly, or other towns because Bergenfield did not have a high school. Harding would later become a junior-senior high school and in 1960 was renamed for Roy W. Brown, the longtime school superintendent. Today, the century-old building is Roy W. Brown Middle School. (Above, courtesy of Howard E. Bartholf; below, courtesy of Eva Gallione.)

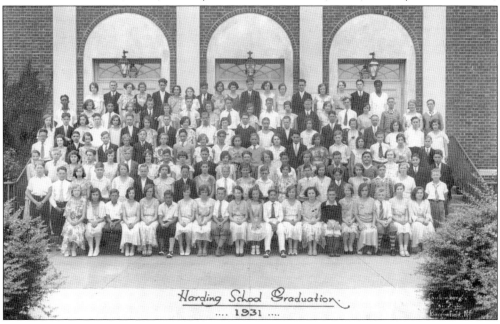

Harding School Graduation.
.... 1931

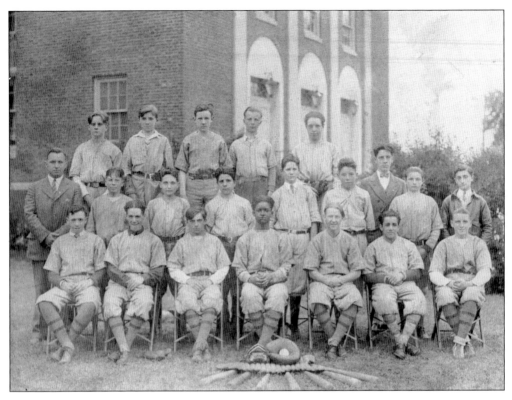

Before the advent of sports leagues, boys hit the diamond representing their schools. Harding School's 1925 baseball team is pictured above. At center in the seated row is Anderson Drakeford, a son of one of the few Black families residing in town. Below, Harding's harmonica club strikes a melody. (Above, courtesy of Eva Gallione; below, courtesy of the Bergenfield Museum.)

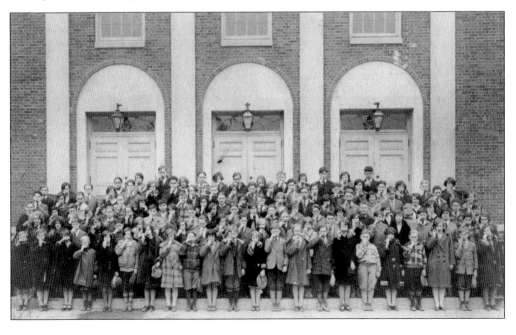

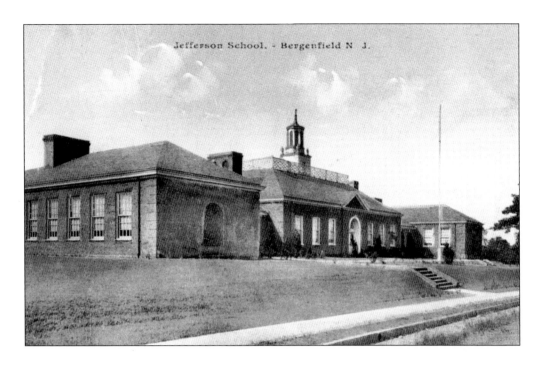

In the 1920s, Bergenfield's growth spread toward the perimeters, making additional elementary schools necessary. Jefferson School, above, was constructed in 1927 on Hickory Avenue in the northeast section; the elaborately costumed student play pictured below occurred in 1930. Two more elementary schools would follow: Lincoln, in the southwest, in 1932 and Hoover, in the southeast, in 1953. (Above, courtesy of the Berdan collection; below, courtesy of the Bergenfield Museum.)

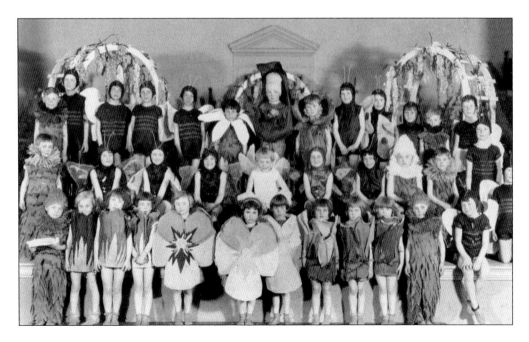

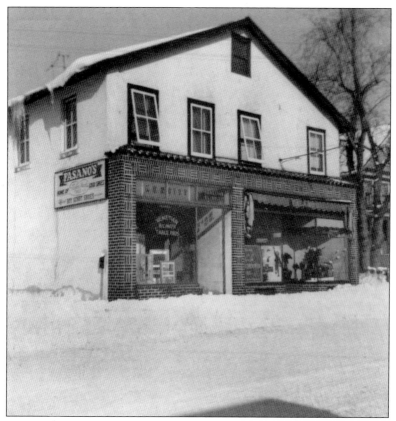

The family-owned Fasano's Shoes was established at 66 North Washington Avenue in 1919 and today is Bergenfield's oldest store. Originally a shoe repair shop, Fasano's switched to selling primarily work boots and casual shoes. Here are early views of the building, left, and its two storefronts, below; Fasano's Shoes is at right. (Both, courtesy of the Fasano family.)

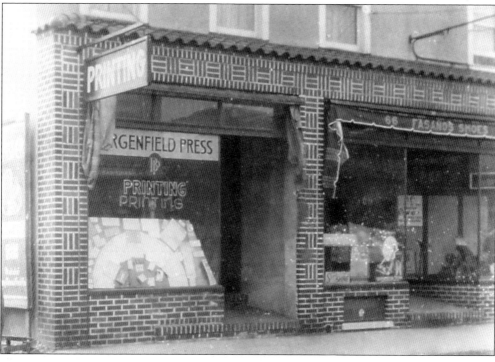

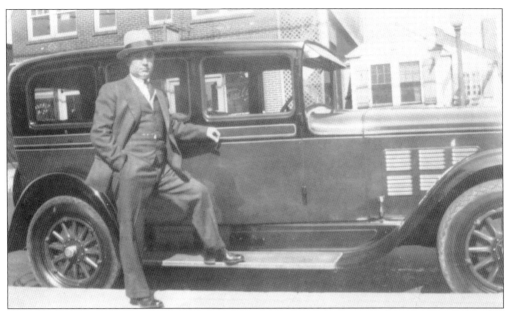

Lorence Fasano left Salerno, Italy, as a teenager to join his father, Michele, who was already plying his cobbler trade in Bergenfield. Lorence followed suit and became one of the borough's most civically involved citizens. In addition to running Fasano's Shoes, Lorence helped establish a transportation system for disabled students and served as school truant officer. Above, Lorence Fasano is pictured in 1930 outside the store; at right, he is relaxing inside the store in the 1990s. (Both, courtesy of the Fasano family.)

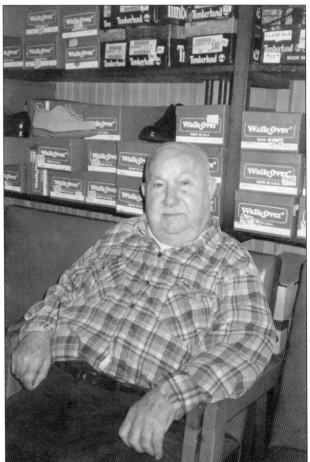

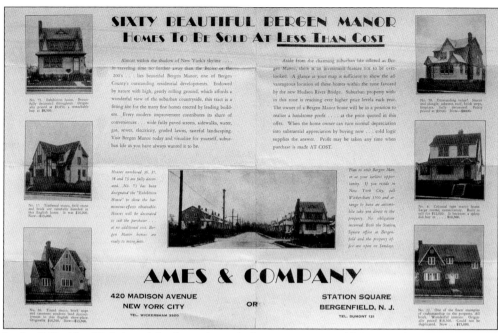

In the 1920s, New York–based developer Ames & Company promised "every modern improvement" and a "charming suburban life" at Bergen Manor, in northwestern Bergenfield. Some of the homes pictured in this advertisement look virtually the same today. (Courtesy of Jolynn Wexler.)

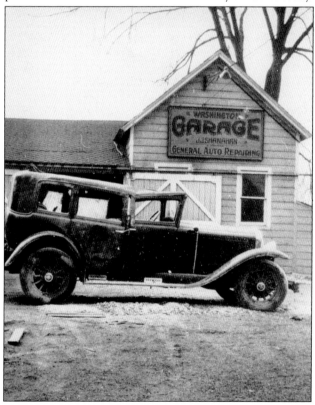

This woebegone vehicle arrived not a moment too soon at Washington Garage in 1932. Three generations of the Shanahan family operated Washington Garage, which provided automotive repair services to the Bergenfield community for many decades. (Courtesy of the Bergenfield Public Library.)

Two

THE BRIDGE
TO SOMEWHERE

Bergenfield . . . made a bid for distinction last night when its Chamber of Commerce gave a banquet, started a drive for a bridge over the Hudson River and formed a New Jersey Hudson River Bridge Association, hoping thereby to get every city, town and community in the state behind the bridge movement. The banquet was held in the Palace Theatre, and over 200 men and women were present. It was the most pretentious affair of the kind ever attempted in Bergenfield and the citizens responded splendidly.

—The *Bergen Evening Record*, November 15, 1923

The George Washington Bridge was bound to be built. But the citizens of Bergenfield, in a burst of civic pride, were fond of playing up their role in conceiving it.

At its first anniversary dinner on November 14, 1923, the Bergenfield Chamber of Commerce vowed to make a bridge to New York City a reality, coining the slogan "Bridge the Hudson" and honoring state senator William Mackay as the event's principal speaker. Over several years, Bergenfield business leaders lobbied New Jersey lawmakers, including Mackay, who sponsored the bill that appropriated $5 million for the bridge's construction. New York lawmakers green-lighted a similar $5 million measure. The $10 million was considered a loan to the bridge's builder, the Port of New York Authority.

"Bergenfield is the birthplace of the campaign," the *Bergen Evening Record* declared in October 1930, one year before New Jersey governor Morgan Foster Larson and New York governor Franklin Delano Roosevelt cut the ribbon opening the 4,760-foot-long span to traffic.

Regardless of how much credit the Bergenfield Chamber of Commerce actually deserved, this much is certain: The bridge transformed the proud borough seven miles yonder.

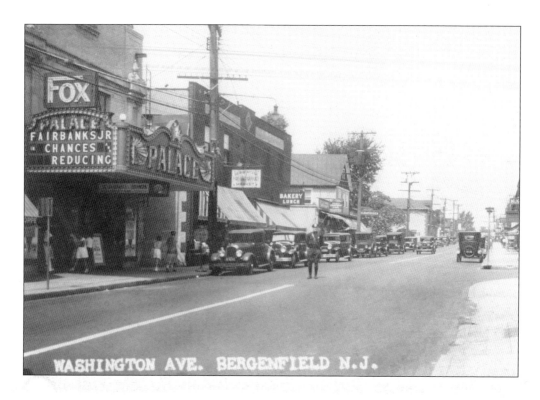

By 1931, when the photograph above was taken, Washington Avenue had supplanted Main Street as Bergenfield's most vital commercial artery. Below, a view of downtown in the 1940s shows fancier streetlights. (Above, courtesy of Michael J. Birkner; below, courtesy of the Berdan collection.)

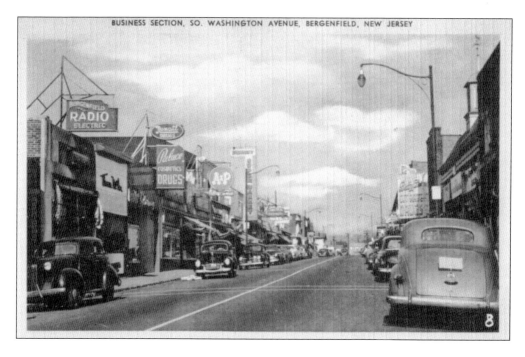

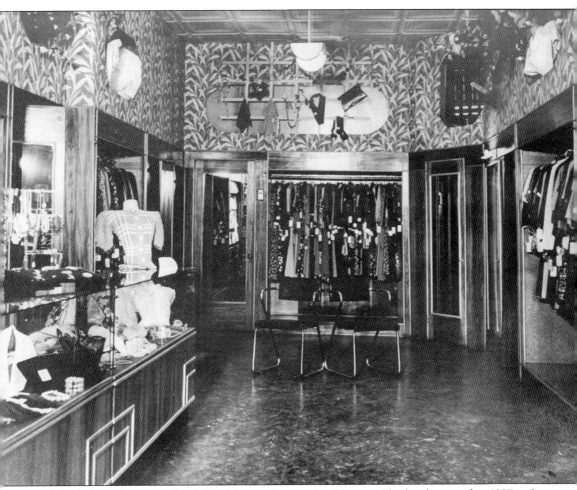

The little dress shop at 29 South Washington Avenue that Florence Eberhardt opened in 1937 and named after herself—the Florence Shop—would grow into a beloved Bergenfield institution and an economic linchpin. Wife of a Wall Street stock clerk and a mother of two, the Brooklyn-born Eberhardt parlayed keen marketing and fashion instincts into business success. (Courtesy of the Bergenfield Museum.)

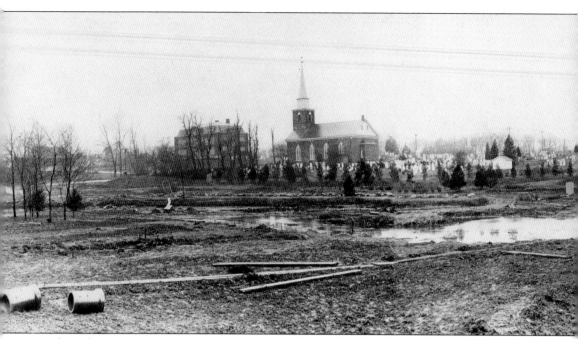

The reclamation of Cooper's Pond and creation of a municipal park around it was one of the most significant projects in Bergenfield history. Funded by a $78,000 grant from the federal Works Progress Administration, the work, which largely involved dredging the pond of silt and weeds, commenced in 1938. South Presbyterian Church donated land on the west bank of the pond for

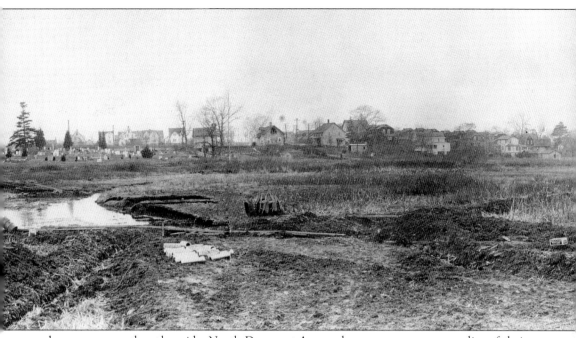

park purposes; on the other side, North Demarest Avenue homeowners gave up a slice of their backyards. This photograph shows a muddy scene while the project was underway. (Courtesy of the Bergenfield Public Library.)

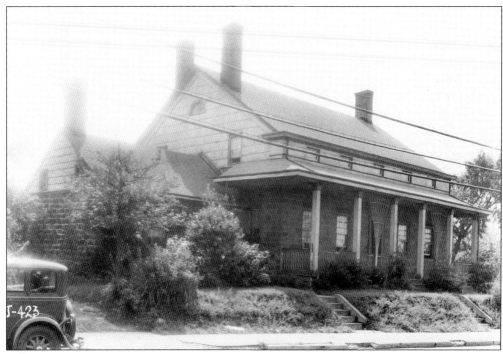

A classic Dutch stone house, the Kipp homestead was located on North Washington Avenue at Merritt Avenue. The 200-year-old residence was razed in 1956, about 20 years after this photograph was taken. (Courtesy of the Bergenfield Public Library.)

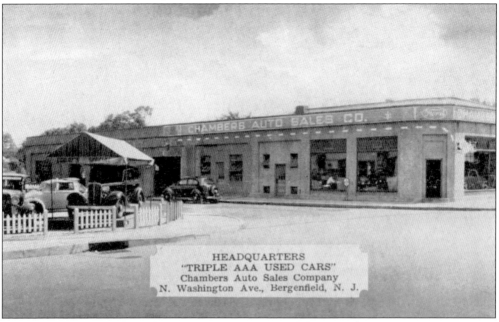

HEADQUARTERS
"TRIPLE AAA USED CARS"
Chambers Auto Sales Company
N. Washington Ave., Bergenfield, N. J.

Automobile dealerships have always been a presence up and down Washington Avenue. Businesses such as Mullane Ford and Weinberg Chevrolet put generations of Bergen County residents into the driver's seat. Mullane and Fisher lasted into the 21st century. But is anyone old enough to remember Chambers Auto Sales? (Courtesy of the Berdan collection.)

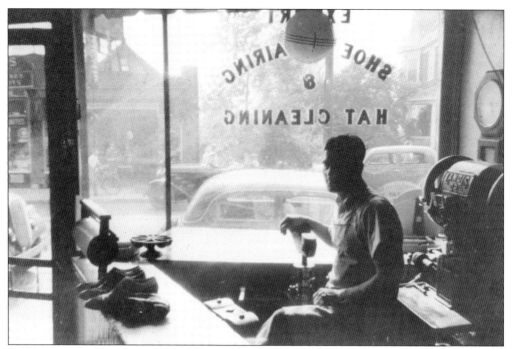

Nick Katasaras, above, is pictured at the workbench of his shoe repair shop at 9 South Washington Avenue in the 1930s. When Katasaras went off to World War II, he asked a friend, Christos Loizides, to mind the store. Loizides, a Greek Cypriot immigrant who previously plied his trade in New York City, eventually bought the business. Below, Loizides, at left, worked in the shop's third Bergenfield location—5 West Main Street—with an employee. Loizides retired in 1986, ending more than 40 years of service to the community. (Both, courtesy of Andy Loizides.)

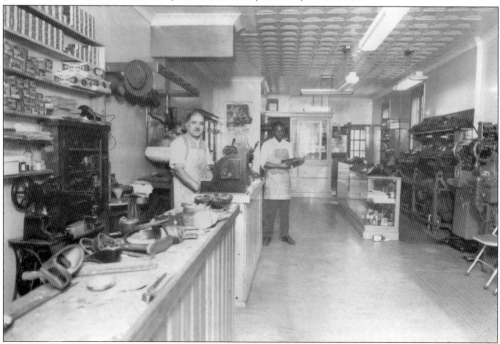

Above, Portland Avenue in the business district was a difficult place to find parking in the 1940s. That was a problem for shoppers. By the next decade, a parking lot was developed at the corner of Portland and Bedford Avenues, below. (Both, courtesy of the Bergenfield Museum.)

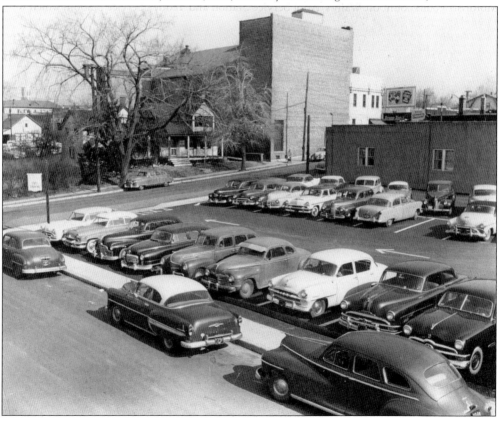

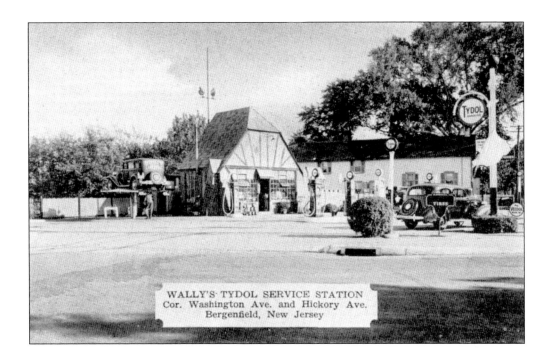

WALLY'S TYDOL SERVICE STATION
Cor. Washington Ave. and Hickory Ave.
Bergenfield, New Jersey

Motorists could count on Wally's Tydol Service Station and Teddy's Service Station, which were located on either end of Washington Avenue. The reverse of Teddy's postcard proclaimed: "We specialize in Blue Sunoco grease jobs—50 cents." Today, gas stations still operate where Wally's and Teddy's stood. (Both, courtesy of the Berdan collection.)

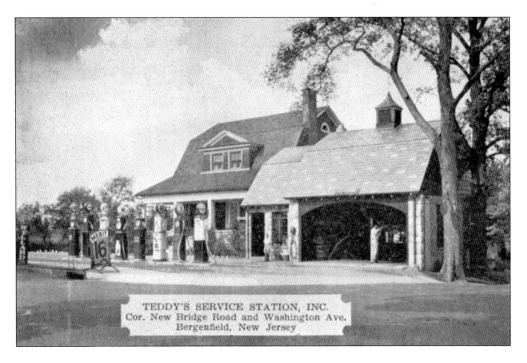

TEDDY'S SERVICE STATION, INC.
Cor. New Bridge Road and Washington Ave.
Bergenfield, New Jersey

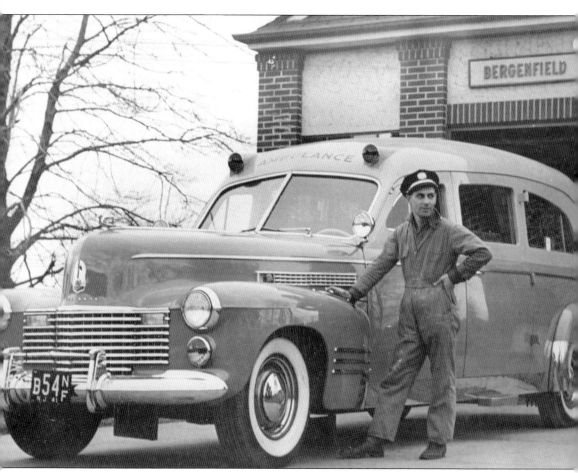

Max London, a charter member of the fire department's volunteer ambulance corps, is pictured with the unit's first ambulance, which was garaged at the firehouse on Home Place. Mayor Frank L. Jones announced the need for a municipal ambulance in 1941, citing the delay in transporting an injured railroad gateman to the hospital. A fundraising drive kicked off on the Fourth of July, and the ambulance was in service by the end of the year. (Courtesy of the Bergenfield Museum.)

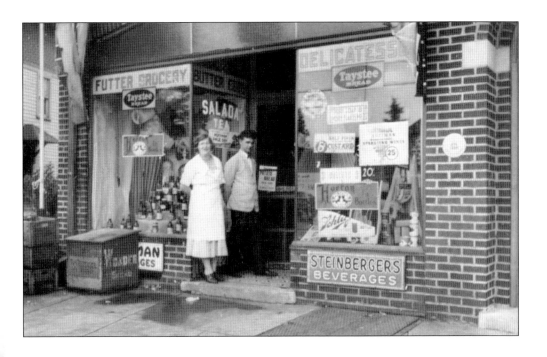

Above, Carl and Josephine Futter stood at the entrance to their Futter Grocery at 142 South Prospect Avenue in the 1930s. The market was later taken over by Josephine's sister Mary Barth and Mary's husband, Ernest, seen below. Since 1963, the business has been Dan's Deli, a favorite of students from the high school. (Both, courtesy of Bill Kirsch.)

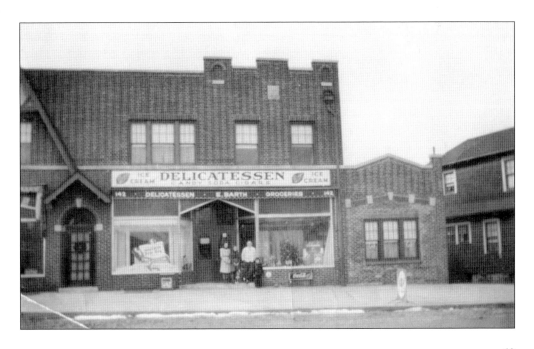

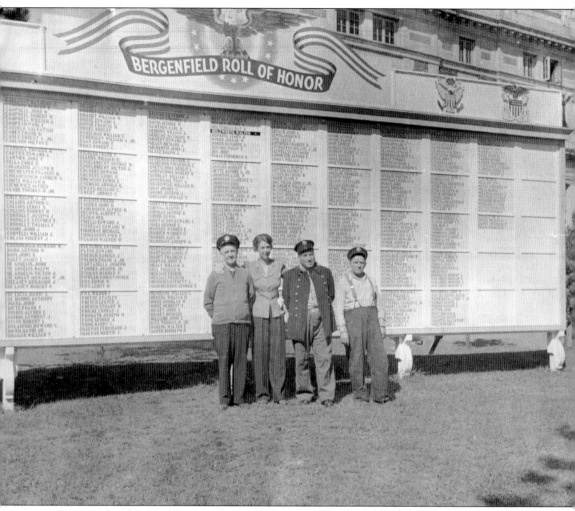

Nine months after Pearl Harbor, Bergenfield unveiled the Bergenfield Roll of Honor board outside the municipal building alphabetically listing borough natives fighting in World War II—474 names to start. The library's Beatrice James headed the committee in charge of the project. She is pictured with three firemen who constructed the board—James Lomax, left; Carmen Constanzo, third from left; and Paul Libonati, right. The name Walter Holzworth is set in black; he was a Marine Corps sergeant killed in the Pearl Harbor attack. (Courtesy of the Bergenfield Public Library.)

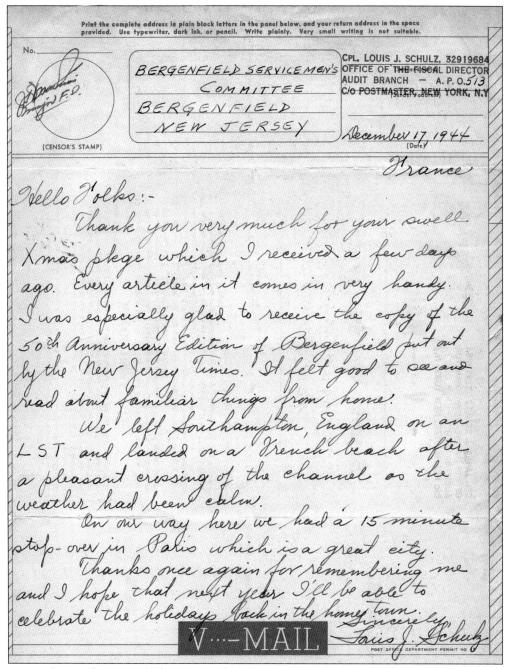

Print the complete address in plain block letters in the panel below, and your return address in the space provided. Use typewriter, dark ink, or pencil. Write plainly. Very small writing is not suitable.

No.

(CENSOR'S STAMP)

BERGENFIELD SERVICEMEN'S
COMMITTEE
BERGENFIELD
NEW JERSEY

CPL. LOUIS J. SCHULZ, 32919684
OFFICE OF THE FISCAL DIRECTOR
AUDIT BRANCH — A. P. O. 513
C/O POSTMASTER, NEW YORK, N.Y

December 17, 1944
(Date)

France

Hello Folks :-
 Thank you very much for your swell Xmas pkge which I received a few days ago. Every article in it comes in very handy. I was especially glad to receive the copy of the 50th Anniversary Edition of Bergenfield put out by the New Jersey Times. It felt good to see and read about familiar things from home.
 We left Southampton, England on an LST and landed on a French beach after a pleasant crossing of the channel as the weather had been calm.
 On our way here we had a 15 minute stop-over in Paris which is a great city.
 Thanks once again for remembering me and I hope that next year I'll be able to celebrate the holidays back in the home town.
 Sincerely,
 Louis J. Schulz

V···MAIL

POST OFFICE DEPARTMENT PERMIT NO 6

During the war, the Bergenfield Servicemen's Committee furnished a canteen for military personnel. The space at 45 South Washington Avenue was outfitted with books, magazine, Ping Pong, and a Victrola. The committee also sent holiday gifts to Bergenfield troops around the world. Here is Cpl. Louis J. Schulz's thank you letter, sent as a V-Mail from France. (Courtesy of the Bergenfield Public Library.)

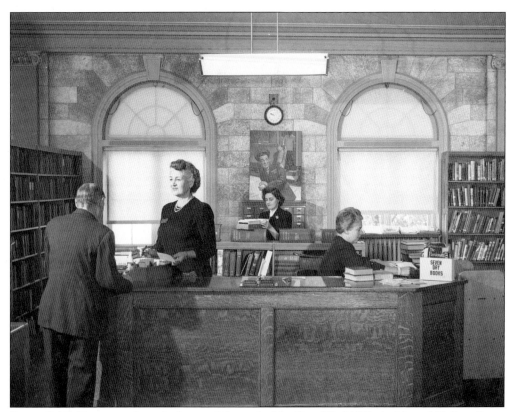

Bergenfield's library was launched toward the end of the First World War in Mutual Hall on Front Street. With an initial collection of 400 books, the library was open for five hours on Tuesdays, Thursdays, and Saturdays. When municipal operations took up residence in the building next to the Knollwood Hotel in 1920, the library moved there; in 1936, the library relocated with other offices to the current borough hall, where these photographs were taken. Above, head librarian Gertrude Lewis, left, helps Daniel Griffin at the circulation desk; assistant librarian Beatrice James sits at right; and in the rear, Christie Murphy checks the card catalog. Below, eager readers gather in the children's section. (Both, courtesy of the Bergenfield Public Library.)

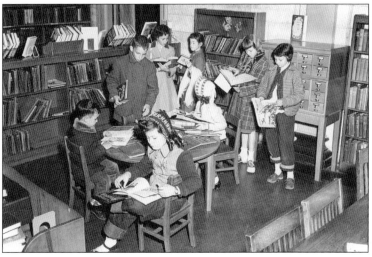

50TH

- 1894 - **- 1944 -**

ANNIVERSARY

Map from an Original Survey done for His Excy. General Washington by Robt. Erskine, F. R. S., Geographer to the Army 1778-1779. Reproduction, Courtesy New York Historical Society and Bergen County Historical Society.

BOROUGH OF BERGENFIELD, N. J.

"Victory! Peace! On Bergenfield's Golden Jubilee"

Bergenfield celebrated its 50th anniversary in 1944, near the midpoint of a decade that saw its population increase from 10,000 to 18,000. This commemorative brochure served as a schedule of special events for the week of September 24. "From an acorn-like hamlet in 1894 our Borough . . . has attained the proportions of a municipal oak," Mayor Frank L. Jones wrote. "Yet with all the changes that have come to any suburb in the shadow of the largest city in the world, our town has retained its early advantages of being near enough to see the reflection of the city's lights, yet far enough away to lose its din." (Courtesy of Howard E. Bartholf.)

1894 - Bergenfield - 1944

50th Anniversary
Municipal Night, September 28th, 1944

•

PROGRAM

OVERTURE..Bergenfield High School Orchestra
Prof. Frank Plocharski, *Conductor*

FLAG SALUTE

INVOCATION...Rev. F. J. Buttery

ADDRESS...Mayor Frank L. Jones

SELECTION..Bergenfield High School Orchestra

PRESENTATION OF PRIZE TO WINNER OF SLOGAN CONTEST

PRESENTATION OF LOCAL AND COUNTY OFFICIALS

GUEST SPEAKER..Senator David Van Alstyne

SELECTION..Bergenfield High School Orchestra

MUSICAL RECORDINGS

MUSICAL REVIEW...St. John's Chorus
Director, Harry S. James
Pianist, Mrs. M. D'Amico

BENEDICTION...Rev. F. J. Buttery

STAR SPANGLED BANNER

Municipal Night, held in the auditorium of the junior-senior high school, was a component of the 50th anniversary celebration. The high school orchestra performed, state senator David Van Alstyne headed a lineup of political luminaries, and the winner of the borough slogan contest was announced. (Courtesy of the Bergenfield Public Library.)

Here is the winning entry in Bergenfield's 50th anniversary slogan contest, open to borough children. The slogan committee winnowed 123 suggestions to two finalists: "1894—Bigger, Better, Busier Bergenfield—1944" and "Victory! Peace! On Our Golden Jubilee." Amid wartime fervor, the latter got the nod but not before some municipal editing—the committee substituted "Bergenfield's" for "Our," making the change on the entry form. The winning slogan was submitted on behalf of Joseph S. Dichiaro, a Washington School first grader. He received a $50 war bond. (Courtesy of the Bergenfield Public Library.)

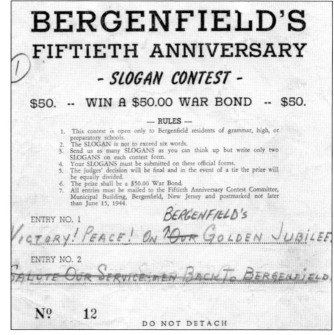

Police Chief Robert Ullrich snapped this photograph after a chimney fire spread through the upper reaches of Washington School, eating through the roof and gutting a second-floor auditorium. The September 26, 1944, calamity occurred on a Tuesday evening while the borough was celebrating its 50th birthday. (Courtesy of the Bergenfield Museum.)

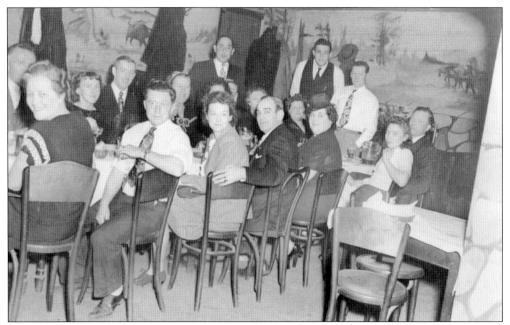

For most of the 20th century, three generations of the Libonati family operated a drinking and eating establishment at 359 South Washington Avenue. The business began as Libonati's Saloon and ended as Lib's Restaurant. Here is a festive Libonati family gathering in the 1940s at what was then called Libonati's Tavern. The owners at the time were Gerald "Gerry" Libonati and George Libonati, sons of Carmine Libonati, founder of the business. Gerry is seated with shirtsleeves rolled up; George is standing at the rear, without vest or jacket. (Courtesy of Janice Sorge.)

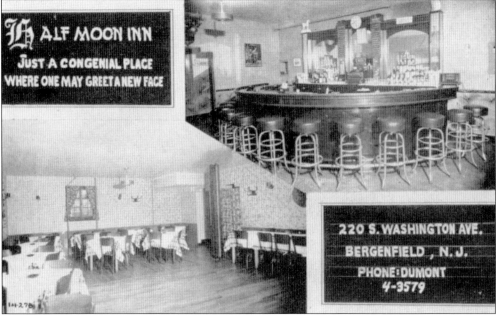

Chicken chow mein, bockwurst—and miniature golf? The Half Moon Inn hosted Rotary Club meetings, Little League dinners, and Christmas parties. Jack A. Boecherer and his son Carl were proprietors of the South Washington Avenue establishment. (Courtesy of the Berdan collection.)

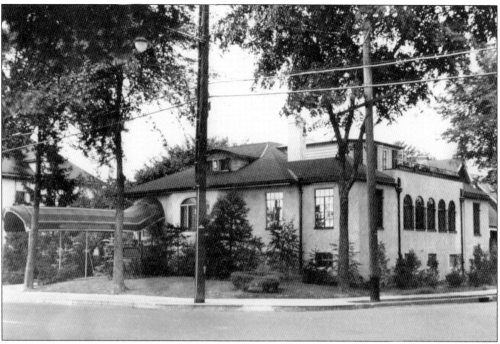

Riewerts Funeral Home is seen above in 1945 after Brar V. "Bud" Riewerts purchased the South Washington Avenue business. Riewerts established himself as an indispensable community member, active in the chamber of commerce, Rotary Club, and South Presbyterian Church. Below, Riewerts wore period garb while riding on a hearse carriage. He sold the funeral home in 1967, but the business has maintained the Riewerts name. (Above, courtesy of Michael J. Birkner; below, courtesy of Maggie Kaplen.)

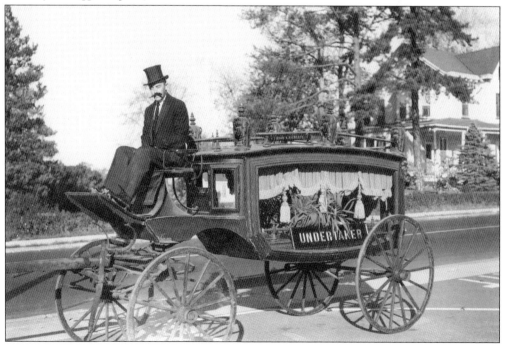

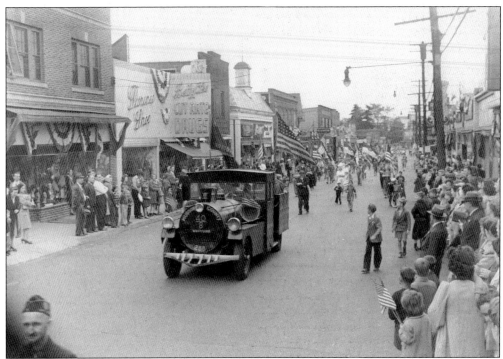

Same holiday, different route. Above, the 1944 Memorial Day parade makes its way up Washington Avenue. Eagle-eyed readers may notice the second location of the Florence Shop, Bergenfield's marquee retailer, next to Betty Lee Drugs. Some years later, below, the scene is residential New Bridge Road, with police officers at the front. (Both, courtesy of the Bergenfield Museum.)

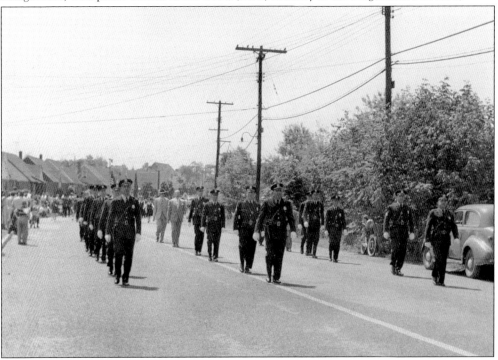

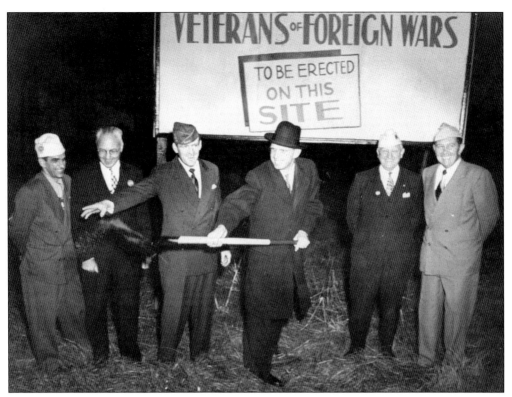

Above, New Jersey governor Alfred Driscoll wielded the ceremonial shovel at the March 2, 1949, groundbreaking for the headquarters of Veterans of Foreign (VFW) Wars Post 6467. The VFW Hall, on South Washington Avenue, is a meeting place for military veterans and a venue for parties and community events. Below, the post's Ladies Auxiliary marched up Washington Avenue in an early 1950s Memorial Day parade. (Both, courtesy of Bergenfield VFW Post 6467.)

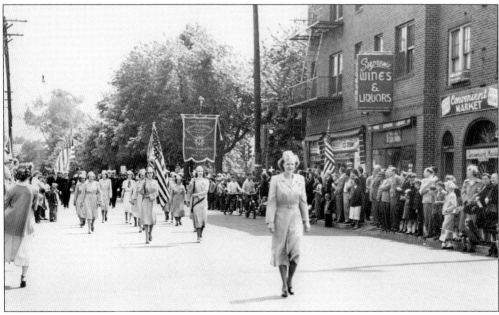

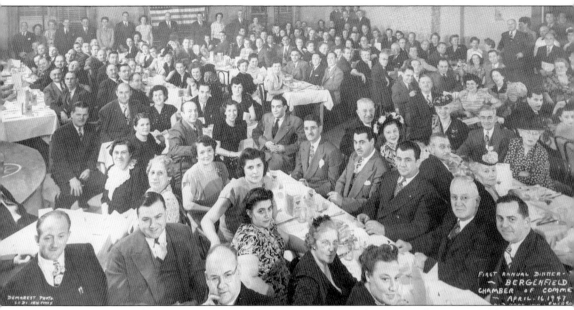

First annual dinner — Bergenfield Chamber of Comme[rce] — April 16 1947

After making a splash campaigning for a bridge across the Hudson River, the Bergenfield Chamber of Commerce went dormant during the Depression. It was not until 1946, a time of postwar growth in the business community, that the chamber was reorganized. That year, the organization sponsored events such as Bergenfield Dollar Days and took out newspaper advertisements inviting shoppers to come downtown. On April 16, 1947, chamber members turned out in force for their first annual dinner-dance. (Courtesy of the Bergenfield Museum.)

Three

A Suburb Takes Shape

Opening of a vast new shopping center on Washington Avenue, Bergenfield, will take place tomorrow with local residents and civic leaders joining in the ceremony to dedicate Bergen County's first completely new commercial project in generations. Proprietors of a wide variety of retail establishments said they were planning special introductory promotions and sales in every one of the 16 shops.

—The *Bergen Evening Record*, June 9, 1949

Emblematic of northern New Jersey's postwar development, Foster Village brought an open-air shopping plaza and 636 garden apartments to Bergenfield—"the largest and finest garden-type apartment house project yet undertaken in Bergen County," its developer boasted.

The complex was created on 40 acres George Foster and his descendants had owned since just after the Civil War. Foster Village provided convenient housing for middle-class families seeking a toehold in the suburbs, and its shopping center, anchored by a Grand Union grocery, augmented Bergenfield's reputation as a retail destination.

Sadly, Foster Village was the scene of one of the darkest days in Bergenfield history—the group suicide of four young people in a carbon monoxide–filled garage on the morning of March 11, 1987.

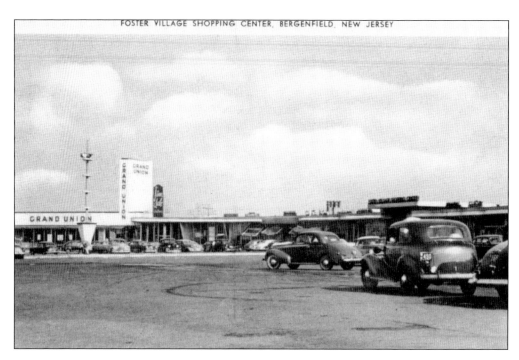

Foster Village Shopping Center at the Bergenfield-Teaneck border opened on June 10, 1949. "Completely modern . . . New Jersey's most beautiful miracle shopping center . . . all stores fully equipped. . . . PARKING SPACE for 500 cars!" crowed the full-page advertisement in the *Bergen Evening Record*. The postcard above shows the newly opened shopping center. Below, the shopping center—remodeled after a 2016 fire—sports a fresh look in 2022. (Above, courtesy of the Berdan collection; below, photograph by Jen Murray.)

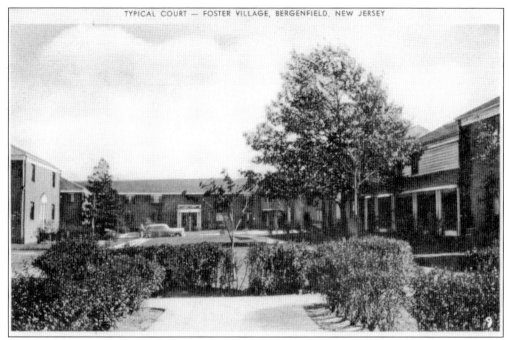

Residents started occupying Foster Village's garden apartments several months before the shopping center opened. By August 1949, nearly all the apartments were taken. Monthly rents ranged from $80 to $115. The redbrick complex's walkways, gardens, lawns, and play areas appealed to urban dwellers from New York City. (Courtesy of the Berdan collection.)

Foster Village meant hundreds of new children for the school system. When Hoover School was built on Murray Hill Terrace, kids living in the garden apartments had a short distance to walk. Principal Rocco R. Montesano is pictured visiting sixth graders in the just opened school in 1953. Montesano would later serve as school superintendent. The high school's athletic stadium bears his name. (Courtesy of the Bergenfield Museum.)

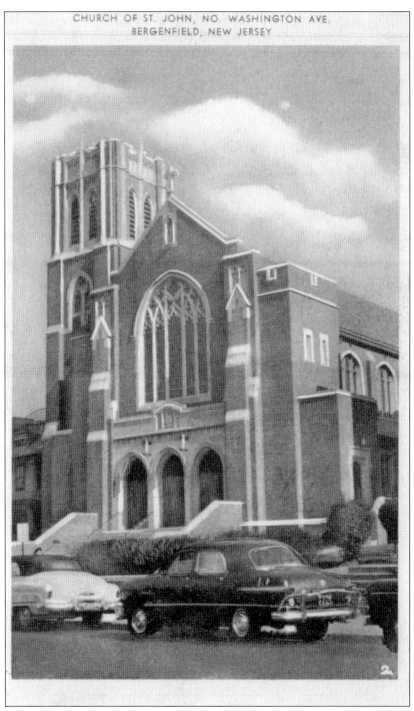

CHURCH OF ST. JOHN, NO. WASHINGTON AVE.
BERGENFIELD, NEW JERSEY

Bursting at the seams due to population growth, the original St. John the Evangelist Catholic Church was torn down in 1949 and replaced by a building with a seating capacity four times greater. The new Gothic-style church, which incorporated some of the old structure's stained glass, was dedicated on December 9, 1950. Today, the parish comprises more than 3,500 families representing many backgrounds. (Courtesy of the Berdan collection.)

Bergenfield-Dumont Jewish Center, the borough's first synagogue, built its new home at 169 North Washington Avenue in 1949, the year Jerome H. Blass began his half-century tenure as rabbi. Blass stood at far right as the conservative congregation burned its mortgage in 1953. Below, youngsters enjoyed a costume party marking the Purim holiday. The Bergenfield-Dumont Jewish Center became Congregation Beth Israel of Northern Valley in 1994 and closed in 2008 upon merging with a synagogue in Teaneck. (Both, courtesy of the Blass family.)

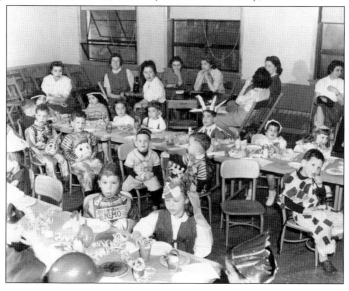

Bergenfield government is at work in 1952. Above, borough clerk Edmund Willis, left, and building inspector Bernard Aschenbrand, center, shared an office on the second floor of borough hall. On the wall between the two windows is the remnant of a gas lamp. Below, tax collector Frank Olson, right rear, worked with his assistant, Ray Johnson (front), in an office on the first floor. A wall-mounted telephone is within reach of department secretary Esther Gormley (left). (Both, courtesy of the Bergenfield Museum.)

Dr. Frank L. Lombardi (seated at desk), health officer, and nurse Ruth Radcliffe (right) checked up on the borough's youngest constituents at the board of health's baby "keep well" station in 1952. Three years later, Lombardi oversaw the inoculation of Bergenfield children against polio. (Courtesy of the Bergenfield Public Library.)

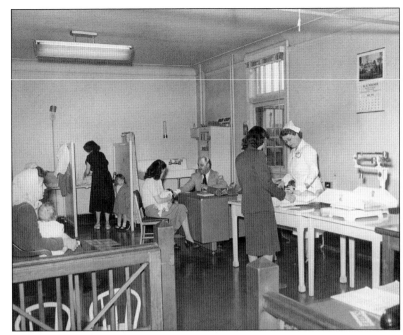

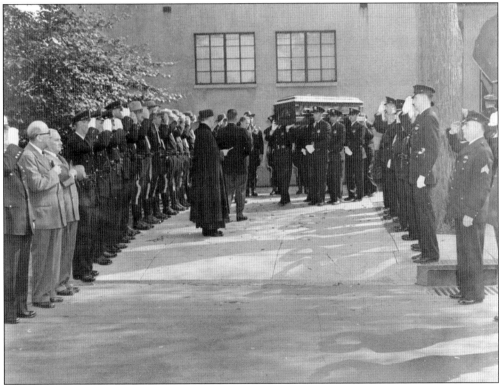

Police officers saluted as Chief Robert Ullrich's casket left Riewerts Funeral Home in September 1952. Ullrich was one of the three original officers when the police department was organized in 1921, along with Scott D. Coombs and Herman Preisinger. Ullrich succeeded Coombs as chief in 1939 and served until his death at age 53. (Courtesy of the Bergenfield Public Library.)

At left, young patrons in Halloween costumes bought tickets at the Palace Theatre in 1955. Note the admission prices ranging from 25¢ to 60¢. That summer, the Palace offered a deal for kids—10 matinees for $1. The holder of the coupon below apparently skipped the final three movies since the stubs were never torn off. (Left, courtesy of Tony DeFeo; below, courtesy of Kurt Luhmann.)

10

PALACE Theatre
BERGENFIELD, N. J.

SUMMER VACATION
CHILDREN'S MOVIES
EVERY THURSDAY MATINEE

DOORS OPEN 1:00 P.M. -- SHOW STARTS 1:30 P.M.
(Starting THURSDAY, JUNE 23 thru
THURSDAY AUGUST 25, 1955)

SPECIAL SEASON TICKET

10 SHOWS FOR } $1.00

THURSDAY MATINEE	SHOW
AUGUST 25	No. 10
THURSDAY MATINEE	SHOW
AUGUST 18	No. 9
THURSDAY MATINEE	SHOW
AUGUST 11	No. 8

Before the Palace Theatre installed a popcorn maker, moviegoers bought their buttery snacks before showtime at the popcorn shop three doors down, above. Eva Kirsch Rieger, below, sold Chuckles, Hershey bars, and other goodies at the theater's snack counter. (Above, courtesy of the Bergenfield Museum; below, courtesy of the Bergenfield Public Library.)

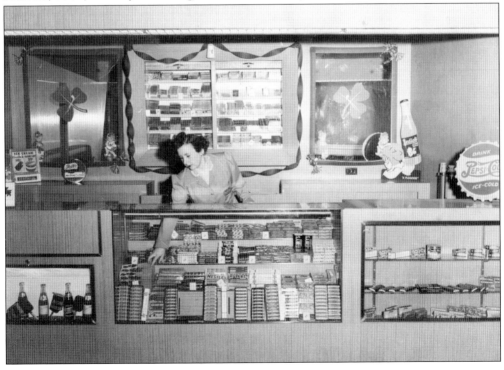

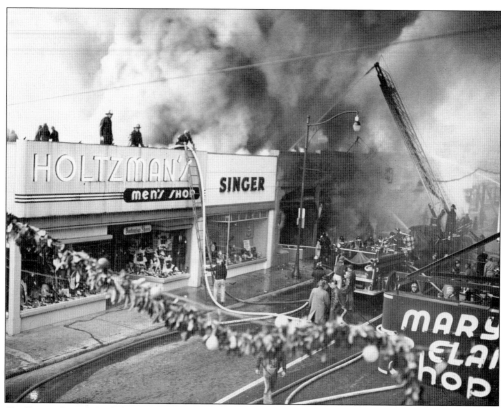

On December 6, 1952, a Saturday afternoon, Washington Avenue was teeming with Christmas shoppers when a fire that originated in a cellar gutted six stores and caused $500,000 in damage. Thirty-one firefighters required medical treatment, most for smoke inhalation. In both photographs, holiday decorations can be seen strung over the avenue. (Above, courtesy of the Bergenfield Museum; below, courtesy of the Bergenfield Public Library.)

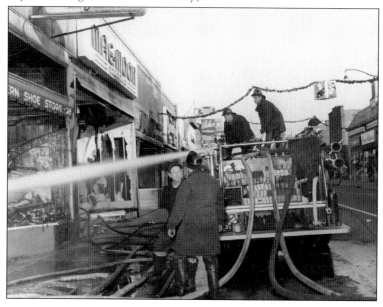

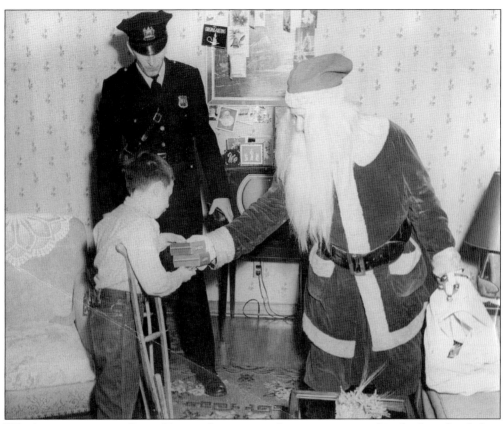

Whether accompanying Santa Claus on home visits, above, or inspecting bicycles for safety, below, these Bergenfield police officers were a presence in the lives of children. (Both, courtesy of Tony DeFeo.)

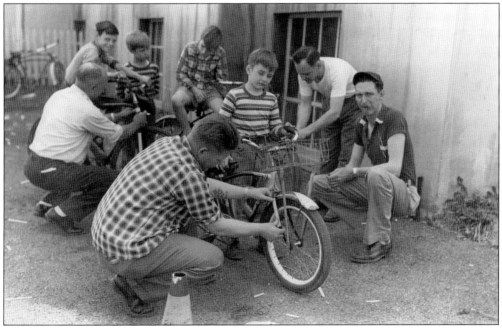

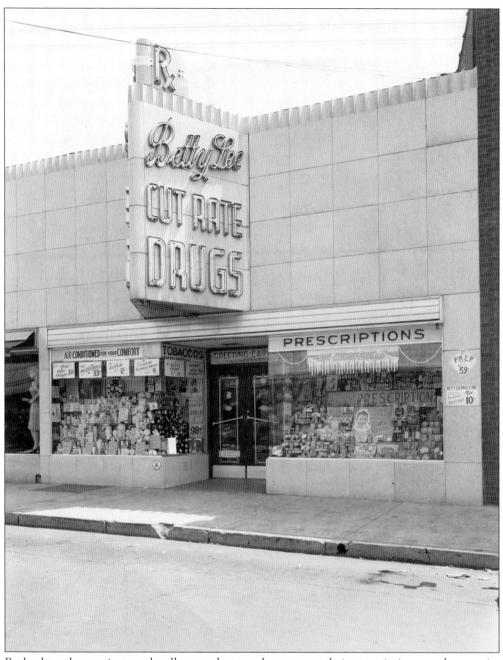

Back when pharmacies were locally owned, many shoppers got their prescriptions—and cosmetics and perfumes—from Betty Lee Drugs, a fixture in the business district for more than 50 years. (Courtesy of the Bergenfield Public Library.)

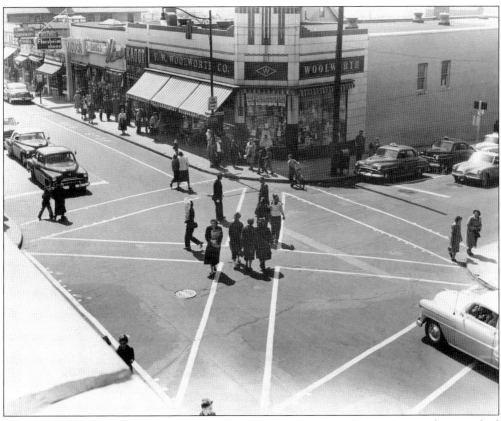

Here is a 1950s view of the intersection of Washington Avenue and Main Street, photographed from the roof of the Florence Shop on the northeast corner. Woolworth's anchored the southwest corner for six decades, until the five-and-dime chain went out of business in 1997. (Courtesy of Michael J. Birkner.)

The Dunkin' Donuts on South Washington Avenue reached all the way to Hollywood for its April 26, 1958, grand opening. That is Buster Crabbe, Olympic swimmer turned movie star, signing autographs. (Courtesy of the Bergenfield Public Library.)

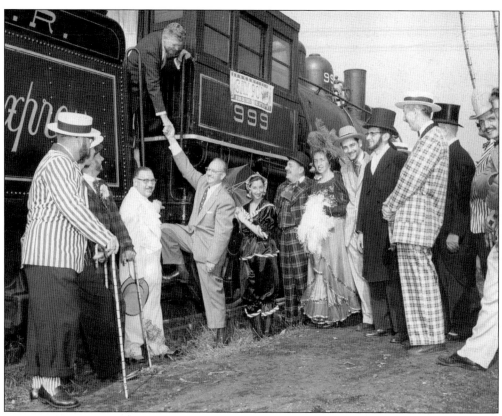

In 1958, the chamber of commerce tossed a Gay '90s Days celebration promising "old-fashioned bargains" at member retailers. Promoting the event featuring costumed store employees, Mayor Edward C. Meyer welcomed a vintage New York Central locomotive to town, above, and sat at the wheel of a classic roadster, below. (Above, courtesy of the Bergenfield Public Library; below, courtesy of the Bergenfield Museum.)

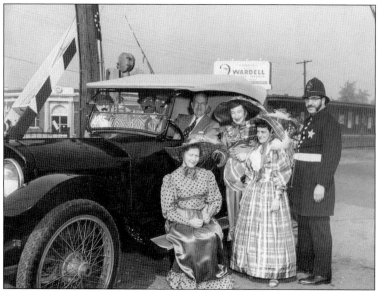

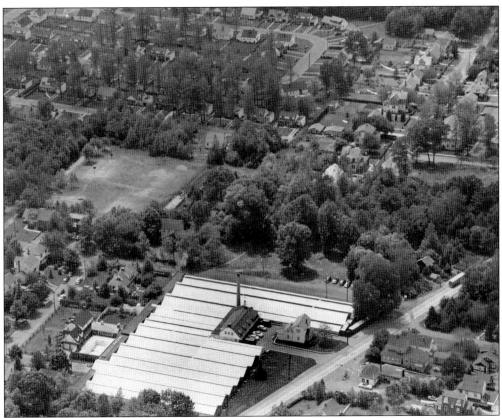

From greenhouses on their East Main Street farm, above, the Patterson family became the largest grower of orchids on the East Coast. Orchidhaven, one of the most distinctive businesses in Bergenfield history, operated until the 1970s, when the land was sold for residential development. At right, Harold Patterson hybridizes a rare orchid in his laboratory. He named many of his hybrids for celebrities, such as Ethel Merman, Jimmy Durante, and Mary Martin. (Both, courtesy of the Bergenfield Museum.)

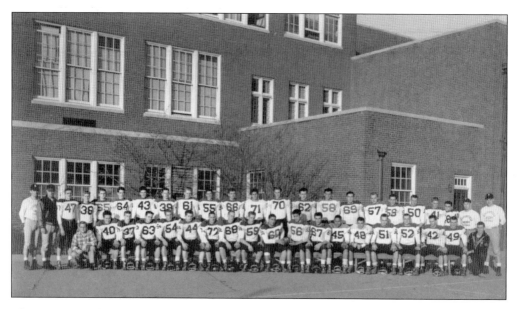

Above, in 1958, the Bergenfield High School football team posed outside the gymnasium of what is now Roy W. Brown Middle School. The cocaptains were Tony DeFeo (60) and Warren Nagaki (56). Three years later, below, the backdrop was the spanking-new high school. Co-captains of the 1961 team were Lenny Pierson (70) and Ronnie Becker (43). (Above, courtesy of Tony DeFeo; below, courtesy of Eva Gallione.)

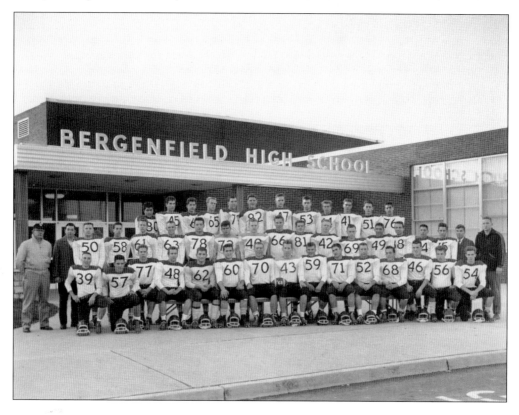

90

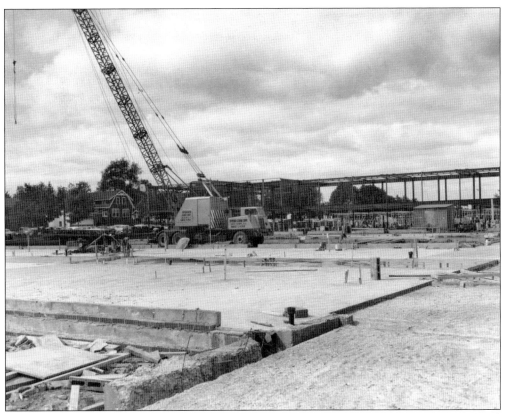

Harding School was expanded in the early 1940s to create a combined junior-senior high school, which allowed Bergenfield's older students to stay in the borough for their education. On May 16, 1957, voters approved a $3.625 million bond issue for a new high school on South Prospect Avenue, shown here during construction. Bergenfield High School opened to its 915 students on October 14, 1959. (Above, courtesy of the Bergenfield Museum; below, courtesy of the Bergenfield Public Library.)

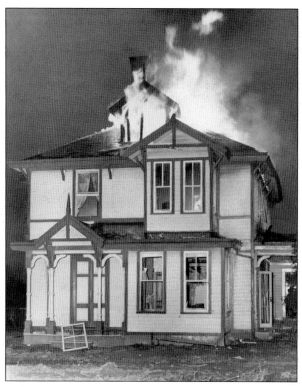

After former mayor Dr. Charles B. Warren moved out of Bergenfield in 1958, his Victorian home was sold to developers and set ablaze as part of a fire department training exercise. Removal of the residence allowed for the creation of a cul-de-sac, Dalton Place. (Courtesy of the Bergenfield Museum.)

Police department and borough brass check out the latest addition to the fleet—a showroom-fresh, unmarked 1958 Chevy. (Courtesy of the Bergenfield Public Library.)

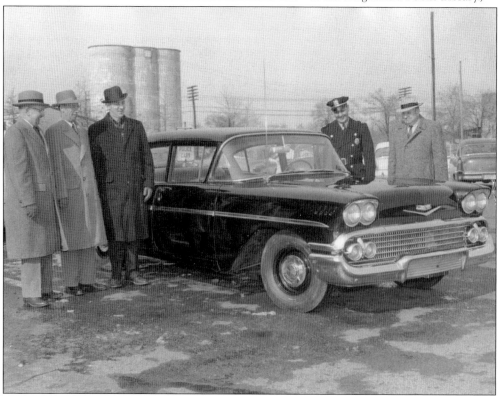

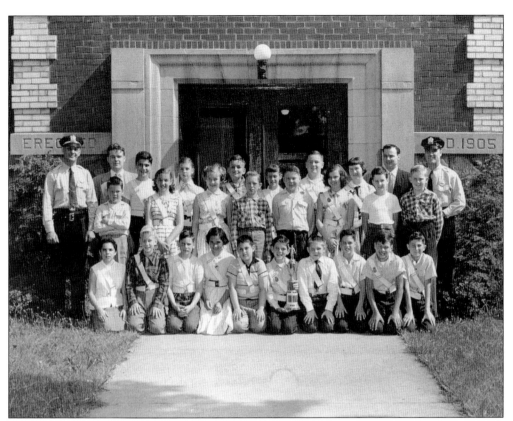

As part of the police department's school safety patrol, students were tasked with reporting hazards such as cracked pavement and broken signs. Above, the pride is evident on the faces of these Washington School patrol members. On March 31, 1958, some 200 patrol members from all Bergenfield grammar schools traveled to Trenton, the state capital, with a state trooper escort. The youngsters met Gov. Robert B. Meyner, and Washington School student John Sands, right, addressed the state assembly. (Both, courtesy of the Bergenfield Public Library.)

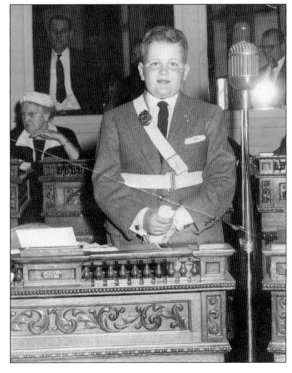

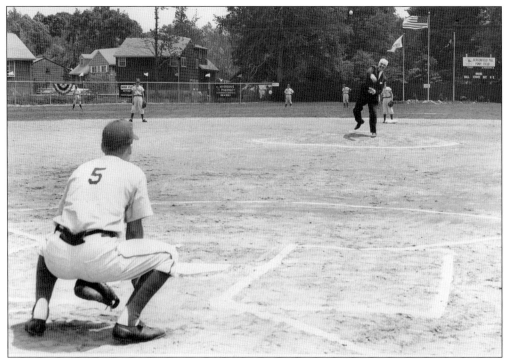

Above, Mayor Hugh M. Gillson tossed out the first pitch at the new Pony League field at the Police Athletic League (PAL) complex in 1961. Four years later, below, night baseball arrived when officials flicked on the field's lights, which were acquired from New York City's dismantled Polo Grounds. At the evening ceremony on July 28, 1965, were, from left to right, Police Chief Edward Jackob; patrolman T.J. Lee, president of the PAL; and Councilmen John Atanasio, William C. Clark, and Charles J. O'Dowd Jr. (Above, courtesy of Michael J. Birkner; below, courtesy of Meg Casper.)

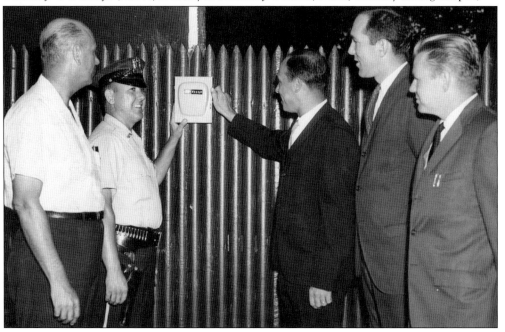

A Manhattan-bound bus is stopped for a red light on Washington Avenue at Main Street in 1962. The bus became commuters' preferred way of getting to work in the city after passenger rail service ended. Washington Avenue remains a busy bus route. (Courtesy of the Bergenfield Public Library.)

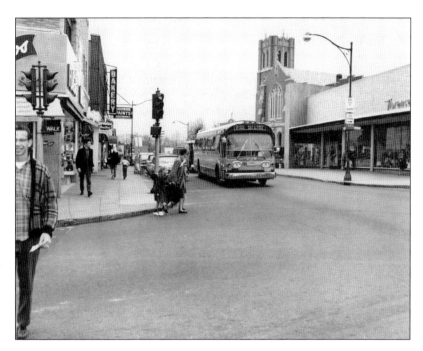

When Alert Fire Company No. 1 needed a new firehouse, the borough offered the West Church Street commuter parking lot, no longer needed after the passenger trains stopped running. Title to the land was conveyed to the Alerts and a sleek headquarters was built there and dedicated on February 3, 1962. Of the 23 company members shown here, 11 would serve as fire chief. (Courtesy of the Bergenfield Museum.)

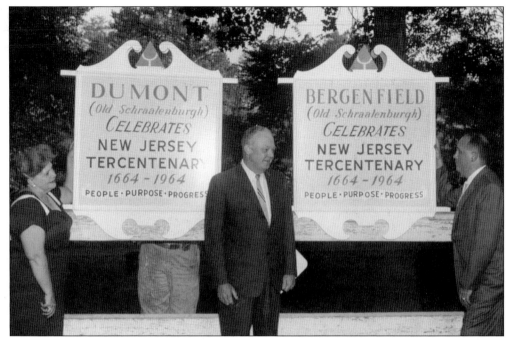

Marking New Jersey's 300th anniversary in 1964, Bergenfield and Dumont, above, unveiled signs that harked back to when the boroughs were one community—Schraalenburgh. Bergenfield mayor William J. Patterson is flanked by the project's committee members, Dumont's H. Jeanne Altshuler and Bergenfield's Norman Bleshman. Below, Carol Turck is crowned Bergenfield's tercentenary queen. Laura Burke of the Junior Woman's Club places the tiara on Turck as Patterson looks on. (Above, courtesy of the Bergenfield Public Library; below, courtesy of the Bergenfield Museum.)

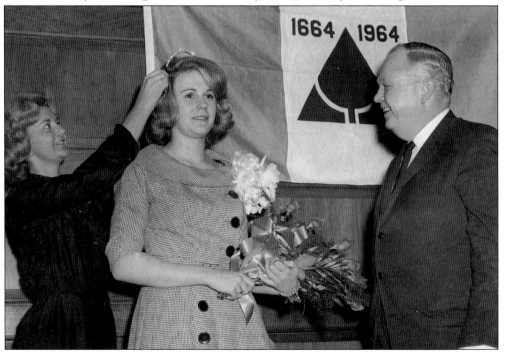

Adrian C. Leiby's book *The Huguenot Settlement of Schraalenburgh: The History of Bergenfield, New Jersey,* was commissioned by the public library and published in conjunction with New Jersey's 300th anniversary. A model of the book was borne on a horse-drawn carriage in the tercentenary parade. Leiby was a partner in a New York law firm and a passionate local historian. (Courtesy of the Bergenfield Public Library.)

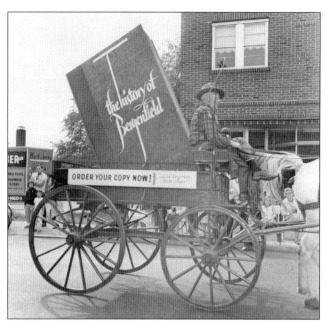

An unknown number of former slaves are interred at the African American Baptist Church Cemetery. The site, at the end of Cedar Street, is part of woodland tract purchased in 1868 by a freed slave, Francis Jackson. The burial ground is seen here the day it was rededicated in 1964, following a cleanup by Boy Scouts who made it their tercentenary project. (Courtesy of the Bergenfield Museum.)

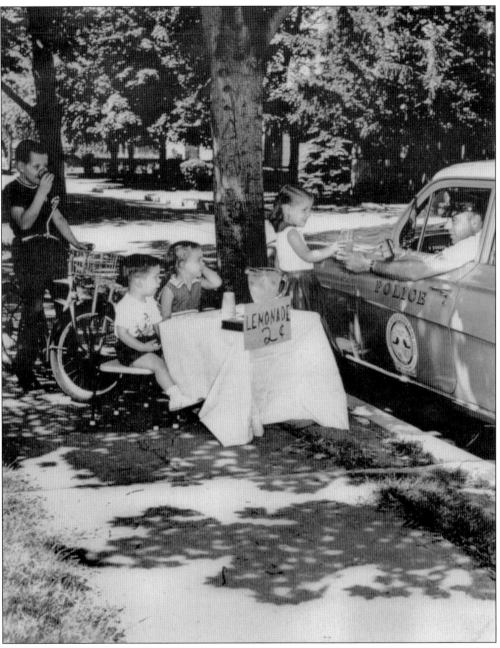

Pictured from left to right, Bob, Bill, Cindy, and Nancy Kirsch had a special customer at their lemonade stand outside their Roosevelt Avenue home: officer Cornelius O'Leary, a colleague of their father, Robert G. Kirsch, who took this photograph. Kirsch, who served on the Bergenfield force from 1950 until his death in 1985, was the records bureau supervisor and police photographer. (Courtesy of the Kirsch family.)

Like the family photograph on the previous page, many police- and fire-related photographs in this book are by Robert G. Kirsch. But not the two here—these show Kirsch himself on the job. "You've got to have a love for photography and for the job to be a police photographer," he told an interviewer. "You get called out at any hour of the day or night." (Both, courtesy of the Kirsch family.)

The Bergenfield Public Library marked Book Week in 1960 with a host of children's programs. Librarian Elizabeth Sutton is shown with three young patrons at a reading display. (Courtesy of the Bergenfield Public Library.)

In the 1960s, Bergenfield began sharing library services with several towns—a precursor to today's Bergen County Cooperative Library System. Here, Lionel Maddeford pulled up in the consortium's delivery van and was greeted by librarian Marie Louise Miller and teenage library page Michael J. Birkner. In 1994, Birkner, a longtime Gettysburg College professor, authored *A Country Place No More*, a history of his hometown and an incisive examination of American suburbanization. (Courtesy of the Bergenfield Public Library.)

Library director Beatrice James, right, accepted a donation of tote bags from members of the Friends of the Bergenfield Library. James started at the library while a Dumont High School student and was named director in 1955. She pushed for the library to get a building of its own and forcefully advocated for government funding of library services. (Courtesy of the Bergenfield Public Library.)

On March 12, 1966, the Bergenfield Police Department celebrated its 45th anniversary with an open house, complete with fingerprinting demonstrations and an up-close look at the tools of the trade. "Children were fascinated with the carbines, shotguns, pistols, and .22 caliber rifle," the *Record* newspaper reported. (Courtesy of the Bergenfield Public Library.)

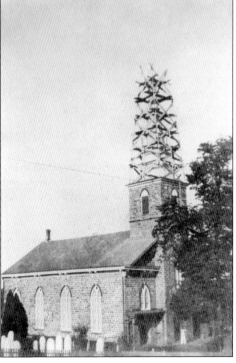

South Presbyterian Church sustained a damaging lightning strike on August 7, 1962. The steeple is seen here during reconstruction. (Courtesy of South Presbyterian Church.)

Four

BUILDING A
BETTER BERGENFIELD

The library bonding ordinance was approved by a 4-2 vote of the Borough Council after a 2½ hour hearing last night. The debate brought out advocates and opponents, including two former mayors, two ministers and a nun, three high school students, several people who said they would pay their opponents' extra taxes, and several politicians of both major parties. The six politicians who had the power of decision listened and watched quietly as 31 of about 350 persons sitting and standing in the Council chamber made their points. If the councilmen were influenced by the debate, it was only to reinforce their already-stated positions, for the same party line division of four Republicans in favor and two Democrats opposed was recorded in the final roll call.

—The *Record*, April 20, 1966

By the 1960s, the public library's quarters in the municipal building were far from ideal, hindering public programming and limiting the size of the collection. Libraries in Dumont, Teaneck, and other nearby towns had buildings all to themselves. But in Bergenfield, the issue of a new library was politically contentious.

Enter the persuasive library director, Beatrice James. She formed a volunteer group, Friends of the Bergenfield Library, to fundraise on the library's behalf. She pushed the planning board to scout for locations. She enlisted consultants. She twisted arms.

In the end, the borough council's vote on the library ordinance was a victory for the community.

Mayor William J. Patterson gleefully plunged the first shovelful of dirt at the groundbreaking for a new library in the block bounded by West Clinton Avenue, Arlington Avenue, Anderson Avenue, and West Front Street. The site—at the center of the borough—had previously been a small park. (Courtesy of the Bergenfield Public Library.)

Above, Beatrice James packed up her office in preparation for the move to the new library building she championed. Below, residents crowded the main floor on opening day in 1968. James, who would serve as library director for another three years, boasted a long list of civic involvements. She lived to 99, and fitting a true Bergenfield grande dame, her funeral included a Dixieland band. (Both, courtesy of the Bergenfield Public Library.)

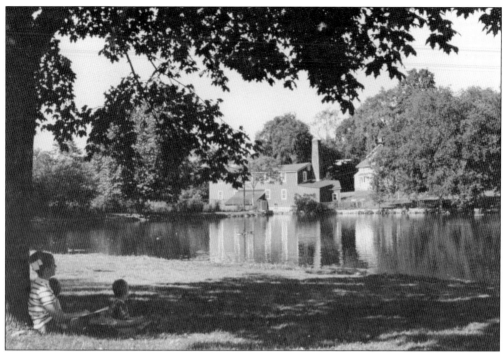

The reclamation of Cooper's Pond paid dividends by creating an idyllic setting for quiet pursuits. Here are two 1960s scenes. The building at the center of the photograph above was the Cooper chair factory. (Both, courtesy of the Bergenfield Public Library.)

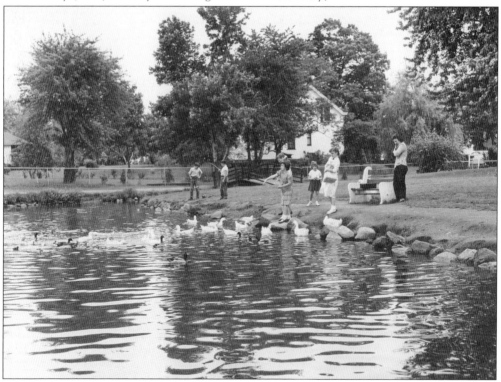

The Clean-Up Bergenfield Committee enlisted young Joyce Solomon in its 1968 campaign to combat litter. Solomon is standing next to a new trash can in the business district. The campaign's mascot was a bear cub—CUB being the acronym of Clean-Up Bergenfield and bear being the mascot of the high school. (Courtesy of the Bergenfield Public Library.)

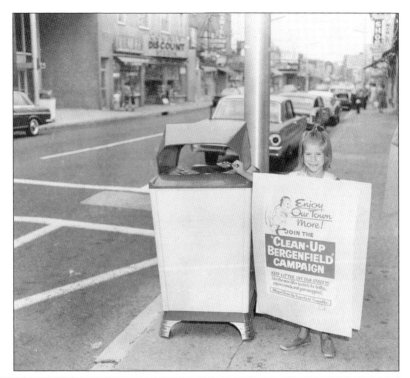

Recruited from Pennsylvania in 1942, Mary Rule was one of Bergenfield's most esteemed teachers. She taught algebra, trigonometry, and plane geometry for 28 years, rising to chair of the high school mathematics department. (Courtesy of the Bergenfield Public Library.)

Highlights of the borough's 75th anniversary celebration in 1969 included the Garden Club's delightful float, above, and luminarias lighting the way for nighttime strollers at Cooper's Pond, below. (Above, courtesy of the Kirsch family; below, courtesy of the Bergenfield Public Library.)

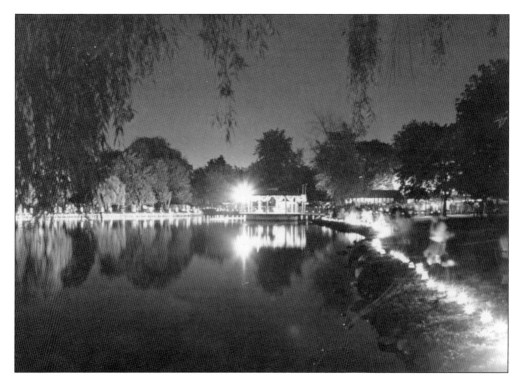

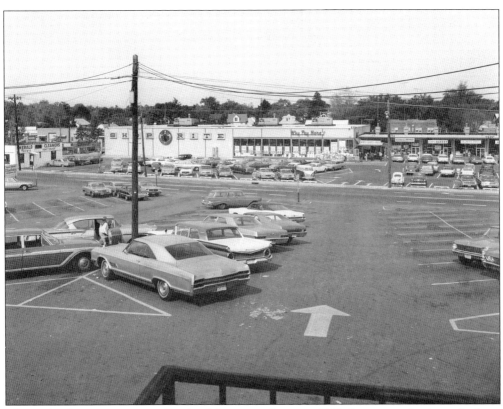

Above, the shopping center on Portland Avenue is shown in 1968, four years after it was built on the site of a former coal and fuel supply business. Its anchor stores today are a pharmacy and a dollar store. Below is the New Bridge Shopping Center on New Bridge Road in 1969. The A&P has been replaced as anchor store by a greengrocer and a kosher market serving the Orthodox Jewish community. (Above, courtesy of the Bergenfield Museum; below, courtesy of the Bergenfield Public Library.)

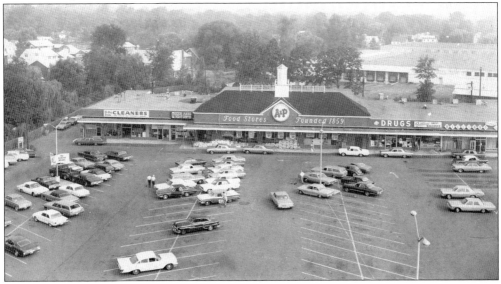

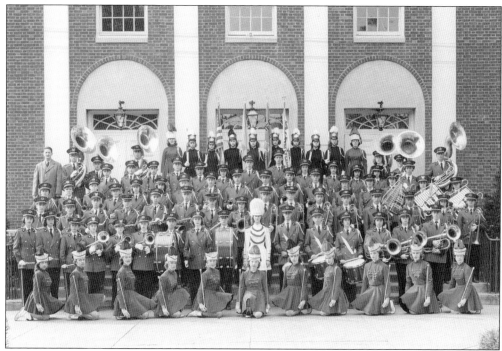

Bergenfield High School is long acclaimed for its instrumental music program and especially the marching band, shown above in 1957 with director Bernard Baggs, at far left wearing an overcoat. Known as "The Music Man," Baggs built the unit from the ground up. He eventually moved into administration, but the marching band did not miss a beat under his successors. Below is Frank Levy leading the band onto the high school field in 1976. (Both, courtesy of the Bergenfield High School Music Department.)

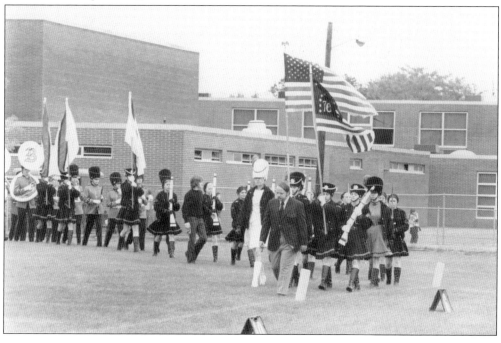

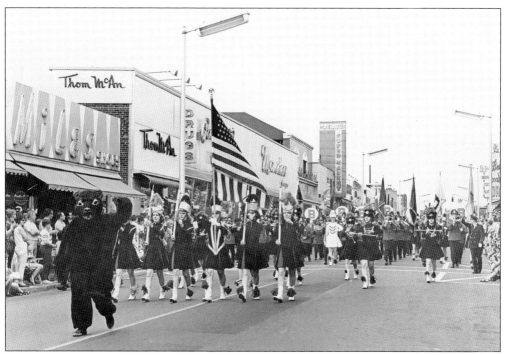

Above, the high school's bear mascot led the marching band in the 1967 Memorial Day parade. Six years later, below, the student musicians wore rain slickers performing at halftime of the New York Jets-Atlanta Falcons football game at Shea Stadium. In 2014, the band added an NFL championship—Super Bowl XLVIII at New Jersey's MetLife Stadium—to an elite resume that also includes 20 appearances in the Macy's Thanksgiving Day Parade. (Above, courtesy of Eva Gallione; below, courtesy of the Bergenfield Museum.)

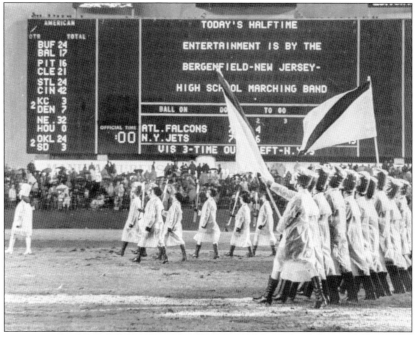

Col. Floyd "Jim" Thompson, the longest held prisoner of war (POW) in US history, was honored by his hometown on Memorial Day in 1973, weeks after his release from a North Vietnamese prison. Thompson, a 1951 graduate of Bergenfield High School, was working at the local A&P when he was drafted into the Army. Initially a rebellious soldier, he warmed to the military and made it his career. Sent overseas in December 1963 for what was to be a six-month tour, Thompson was a passenger on an observation plane downed by small arms fire over South Vietnam on March 26, 1964. He survived with a broken back and other injuries and was captured by the Vietcong, enduring torture and starvation over nine years of captivity. Thompson, who died in 1992, is remembered with a handsome memorial next to the high school athletic field. (Courtesy of the Bergenfield Museum.)

Sidewalk sales sponsored by the now defunct chamber of commerce are a cherished memory for many. Above, a police officer directed traffic at Washington Avenue and Main Street during a 1968 sale; below, shoppers browsed nearly elbow to elbow in 1990. (Above, courtesy of Jules Orkin; below, courtesy of Bill Slossar.)

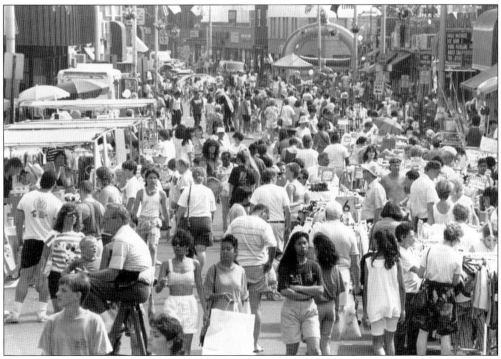

The Florence Shop, pictured above in the 1970s, was a magnet for shoppers from well beyond Bergenfield. Florence Eberhardt opened a small dress shop at 29 South Washington Avenue in 1937. The store moved to larger quarters at 19 South Washington Avenue in 1942. Expansion to a newly constructed department store at the corner of Washington Avenue and Main Street occurred in 1952. Before the first shopping malls opened in nearby Paramus, this women's and children's wear emporium was Bergen County's largest retail store. Below, the hands-on Eberhardt is seen at left with Nell Barrett, one of the store's buyers. (Both, courtesy of the Eberhardt family.)

Above, it was not the holiday season in Bergenfield until Santa Claus descended from the Florence Shop roof. The store's parking lot also was the scene of holiday activity, such as the Halloween parade below. (Above, courtesy of the Bergenfield Public Library; below, courtesy of the Bergenfield Museum.)

In the early 1970s, the Catholic Youth Organization at St. John's Church raised money for good causes by performing such deeds as collecting paper and washing cars. The church is shown in the photograph above, and a Bergenfield police vehicle is being cleaned in the photograph below. (Both, courtesy of Meg Casper.)

Patrolman T.J. Lee, longtime president of the Police Athletic League, is joined by a young flag bearer in the 1976 Memorial Day parade. This photograph was displayed in the store they are passing, Irving's Shoes, where Bergenfield youngsters got their Buster Browns and Keds. (Courtesy of Meg Casper.)

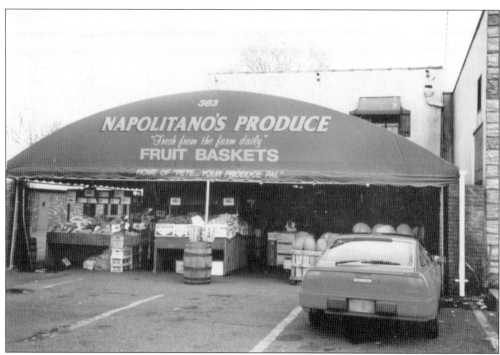

Napolitano's Produce was a Bergenfield institution for more than 50 years, starting in 1953 when Peter Napolitano Sr. sold watermelons off his truck. By 1959, the family had a store at 323 South Washington Avenue, above. Below is the store's second-generation owner, Peter Napolitano Jr.—nicknamed Produce Pete—whose folksy manner and encyclopedic knowledge of fruits and vegetables have served him well as a television personality and author. (Both, courtesy of Peter Napolitano Jr.)

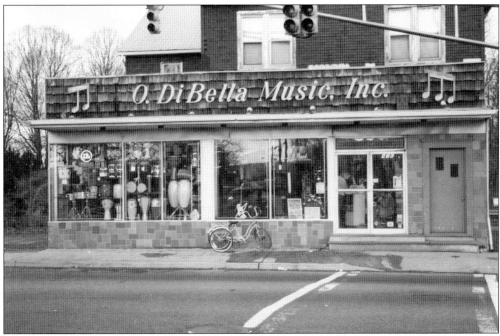

Established by Onofrio DiBella in 1910, O. DiBella Music is one of the nation's oldest family-run music stores. The business relocated to Bergenfield from New York City in 1968. The original Bergenfield store on South Washington Avenue at the Teaneck border is seen above. A much larger showroom replaced it in 1999. Below, the second- and third-generation owners, Michael DiBella Sr. (right) and Mike DiBella (center), are pictured with employee Jim Krazit (left) in the 1980s. (Both, courtesy of Mike DiBella.)

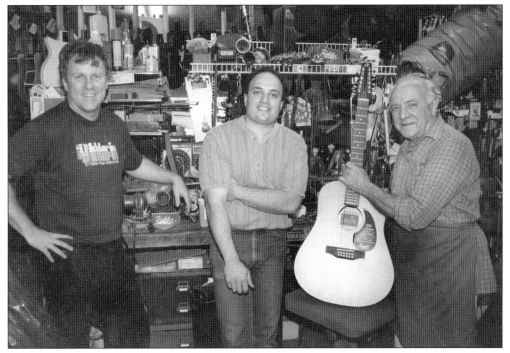

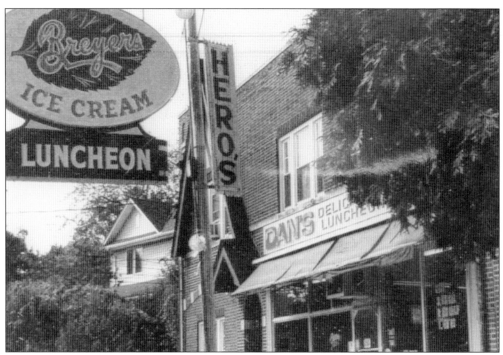

In 1963, brothers Vito and Frank Florio purchased the small store at 142 South Prospect Avenue and rechristened it Dan's Deli in honor of their father. The storefront in its early years is shown above; below, the Florio clan gathered for a celebration on both sides of the deli's counter, with Frank at far left and Vito, wearing glasses, at far right. The Florio family owned Dan's Deli for more than 40 years. The business, still named Dan's Deli, is a favorite of Bergenfield High School students who come for buttered rolls, coffee, and lunch. (Both, courtesy of JoAnne Zucconi.)

25¢
WEDNESDAY
MARCH 11, 1987

4 teens commit suicide

By The Record's staff

Four teen-agers were found dead in a garage in Bergenfield this morning, victims of an apparent suicide pact, Bergen County Prosecutor Larry McClure said.

The four — two young men and two young women — apparently locked their car in a garage at the Foster Village apartment development and committed suicide by carbon monoxide asphyxiation, McClure said. A note was found, McClure said, but he would not reveal its contents.

The four ranged in age from 16 to 19, he said. He would not disclose their identities, pending family notification. McClure had scheduled a news conference for this afternoon.

Reporters in back of the Foster Village apartments on Howard Drive said Bergenfield police and investigators from the prosecutor's office were examining a rust-colored Camaro in which the four bodies were found.

Other witnesses said police arrived at the scene shortly before 6:30 this morning and forced open the garage. They removed a male from the driver's side

See 4 TEEN-AGERS, Page A-16

The carbon monoxide deaths of four teenagers in a Foster Village garage on March 11, 1987, thrust Bergenfield into an unwelcome national spotlight. The victims—three who dropped out of Bergenfield High and one who was suspended from the school—had entered into a suicide pact. Jolted by the tragedy, the grief-stricken community set out to answer the questions: How did we fail these troubled young people? And how can we prevent such a thing from happening again? (Courtesy of the Bergenfield Public Library.)

Frank Eufemia, class of 1977, is the first Bergenfield High School product to play major-league baseball. The right-handed relief pitcher made his one season a productive one; he went 4-2 with two saves for the 1985 Minnesota Twins. Above, Eufemia shook hands with John Glenn when the Ohio senator visited Bergenfield during his campaign for president. (Both, courtesy of Frank Eufemia.)

FLEER

FRANK EUFEMIA
PITCHER

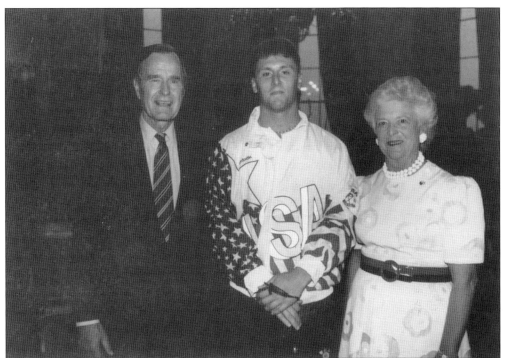

Ron Villone, who graduated from Bergenfield High in 1988, pitched for Team USA in the 1992 Barcelona Olympics before embarking on a well-traveled big-league career. Primarily a reliever, the lefty compiled a 61-65 record over 15 seasons. In 2006 and 2007, he played close to home for the New York Yankees. Above, the young Olympian met Pres. George H.W. Bush and First Lady Barbara Bush at the White House. (Both, courtesy of the Bergenfield Museum.)

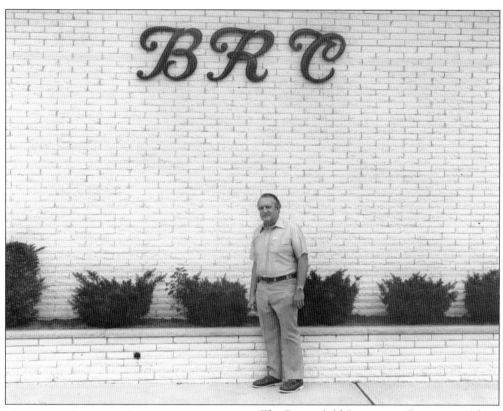

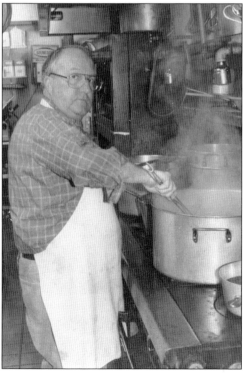

The Bergenfield Recreation Center, an 18-lane bowling alley and bar and grill on Legion Drive, was owned for nearly three decades by Tom Power and, before that, by his wife's family, the Guerras. Power is seen here outside the recreation center with its distinctive script "BRC" logo (above) and cooking in the kitchen (left). An exemplar of conviviality and community spirit, Power let groups use the facilities free of charge and championed youth bowling. The business closed in 2005. (Both, courtesy of the Power family.)

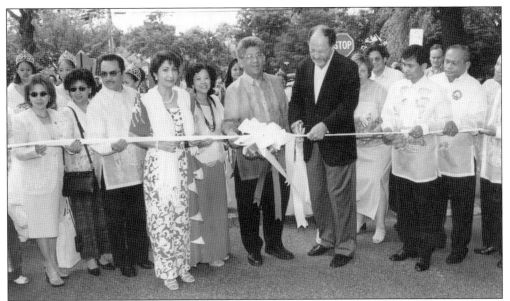

Robert Rivas, center left, became Bergenfield mayor in 1998—the first mayor of Filipino descent on the East Coast. Rivas is pictured here with New Jersey senator Jon Corzine, center right, and Filipino community members at a ribbon cutting. Beginning with a wave of arrivals in the 1980s, a time of financial turmoil in the Philippines near the end of Ferdinand Marcos's rule, the Filipino American community has surged to 18 percent of Bergenfield's population. The borough's second Filipino American mayor, Arvin Amatorio, took office in 2020. (Courtesy of Robert Rivas.)

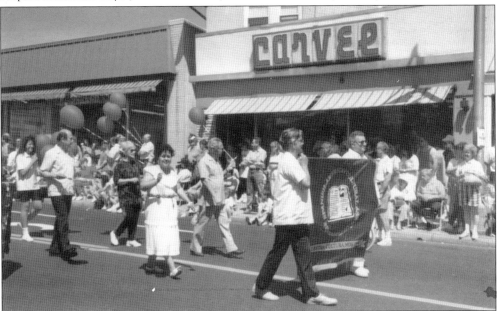

Once predominantly Italian and Irish, Bergenfield has grown more diverse in recent decades. Today, the borough has sizable Filipino, Hispanic, and Orthodox Jewish populations. Here, the Hispanic community is represented by the Spanish American Cultural Association of Bergenfield, whose members carried the organization's banner in the 1989 Memorial Day parade. (Courtesy of Anna Ramirez.)

It is the end of an era. The Florence Shop, a victim of competition from the giant shopping malls, closed in 1994, three years after the death of its namesake and founder, Florence Eberhardt. (Courtesy of Jules Orkin.)

When the mercury plunges low enough, Cooper's Pond transforms into a skating rink, and Bergenfield kids get to play hockey in the shadow of a historic landmark. (Courtesy of the Bergenfield Museum.)

ABOUT THE BERGENFIELD MUSEUM

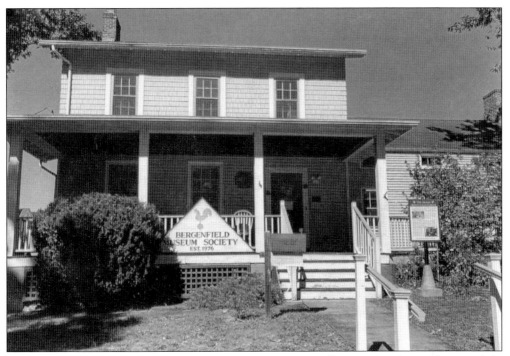

In 2013, the Bergenfield Museum Society relocated its extensive collection of artifacts and memorabilia to the house at the north end of Cooper's Pond once owned by chairmaker Tunis R. Cooper. The Bergenfield Museum, which provided many photographs for this book, is open to visitors Tuesday and Saturday afternoons and Sundays by appointment. The society welcomes memberships and donations to further its important work preserving Bergenfield's history.

Bergenfield Museum
100 Cooper Street
PO Box 95
Bergenfield, New Jersey 07621
bergenfieldmuseumsocietynj@gmail.com

DISCOVER THOUSANDS OF LOCAL HISTORY BOOKS FEATURING MILLIONS OF VINTAGE IMAGES

Arcadia Publishing, the leading local history publisher in the United States, is committed to making history accessible and meaningful through publishing books that celebrate and preserve the heritage of America's people and places.

Find more books like this at
www.arcadiapublishing.com

Search for your hometown history, your old stomping grounds, and even your favorite sports team.

Consistent with our mission to preserve history on a local level, this book was printed in South Carolina on American-made paper and manufactured entirely in the United States. Products carrying the accredited Forest Stewardship Council (FSC) label are printed on 100 percent FSC-certified paper.

MADE IN THE USA